AN INTRODUCTION TO

The Arts
in Canada

ISBN 0 7730 4028 5 (paper)
 0 7730 4029 3 (cased)

Design/Pat Dacey
Cover Photograph/ Norman Bevetzin

Copp Clark Publishing
517 Wellington Street West
Toronto M5V 1G1

Printed and bound in Canada
1 2 3 4 5 #140590 (paper) 81 80 79 78 77
1 2 3 4 5 #140591 (cased) 81 80 79·78 77

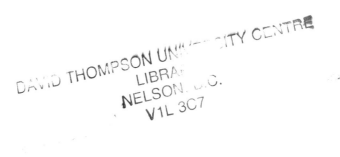
Front endpaper: (upper left) Lawren Harris: *Icebergs, Davis Strait.* Courtesy of the McMichael
Canadian Collection. (upper right) Alfred Pellan: Detail from *L'Affût.* Oil on canvas. The
National Gallery of Canada, Ottawa. (lower left) William Kurelek: from *A Prairie Boy's
Summer,* © 1975 William Kurelek. Courtesy of Tundra Books of Montréal. (lower right) Alex
Colville: Detail from *Hound in Field.* Casein tempera on board. The National Gallery of
Canada, Ottawa.

AN INTRODUCTION TO
The Arts in Canada

by Robert Fulford

Published by Copp Clark Publishing, in association with
the Citizenship Branch, Department of the
Secretary of State of Canada, and Publishing Centre,
Supply and Services Canada.

Acknowledgements

Every effort has been made to ensure the accuracy of these Acknowledgements. If an error or omission has been made, the publishers would appreciate knowing so that they might correct it.

1 Beliefs and Hopes and Fears
(facing p. 1) Close-up of Rufus Moody's hands as he carves out of argillite, Queen Charlotte Islands, B.C. Photo by Chris Lund, courtesy of NFB Photothèque.
pp. 2-3 – Three views of totem poles in Totem Park, Prince Rupert, B.C. Photos by Chris Lund, courtesy of NFB Photothèque.
p. 4 – Two views of Indian rock hieroglyphics in the Lake Superior, Ontario area. Photos by Mia & Klaus, courtesy of NFB Photothèque.
p. 5 – (left) Woven beaded knee bands. Photo courtesy of National Museums of Canada.
p. 5 – (right) Birch bark plate, quilled. Photo courtesy of National Museums of Canada.
p. 6 – Indian artist Sam Wesley, carving a wooden head covering at K'San, B.C. Photo by Crombie McNeill, courtesy of NFB Photothèque.
p. 7 – Indian artist Gerald Marks, engraving a silver bracelet in Delta, B.C. Photo by Crombie McNeill, courtesy of NFB Photothèque.
p. 9 – Alex Janvier: *The Doggone Weakbacks* (1975). Acrylic on canvas. Photo courtesy of the McMichael Canadian Collection.
p. 10 – Daphne Odjig: *The Embrace* (1975). Acrylic on canvas. Photo courtesy of the McMichael Canadian Collection.
p. 11 – Norval Morrisseau: *Self-Portrait* (1975). Acrylic on masonite. Photo courtesy of the McMichael Canadian Collection.
p. 13 – Soapstone carver at work, Eskimo Point, N.W.T. Photo by John Reeves, courtesy of NFB Photothèque.
p. 14 – (left) Leah Eevik, Pangnirtung: untitled whalebone/stone sculpture. Photo courtesy of the McMichael Canadian Collection.
p. 14 – (right) Keawak, Cape Dorset: untitled greenstone sculpture. Photo courtesy of the McMichael Canadian Collection.
p. 15 – Artist unknown: dark grey stone sculpture. Photo courtesy of the McMichael Canadian Collection.
p. 16 – (left) Kiakshuk, Cape Dorset: *Strange Scene* (1964). Stone cut. Photo courtesy of the McMichael Canadian Collection.
p. 16 – (right) Kananginak, Cape Dorset: *Umingmuk* (1973). Stone cut. Photo courtesy of the McMichael Canadian Collection.
p. 17 – Pitseolak, Cape Dorset: *Trip to Toodja* (1973). Stone cut. Photo courtesy of the McMichael Canadian Collection.

2 Stories Out There
p. 20 – Morley Callaghan. Photo courtesy of the Macmillan Company of Canada Ltd.
p. 21 – Pierre Berton. Photo courtesy of CBC Picture Service.
p. 22 – Scene from *The Apprenticeship of Duddy Kravitz* by Mordecai Richler, starring Richard Dreyfus. Photo courtesy of Consolidated Theatre Services.
p. 23 – Mordecai Richler and son, reading from *Jacob Two-Two Meets the Hooded Fang* at the Children's Book Store, Toronto. Photo courtesy The Toronto Star.
p. 25 – Leonard Cohen with his guitar at Expo, Montréal. Photo by Dunkin Bancroft, courtesy of NFB Photothèque.

p. 26 – Margaret Laurence at an autographing session at the Longhouse Book Shop, Toronto. Photo by Lori Spring.
p. 28 – A view of the Montréal International Book Fair. Photo by Fiona Mee, courtesy of *Quill & Quire*.

3 Life to be Discovered
p. 30 – (top left) Roch Carrier. Photo from l'Office du Film du Québec, courtesy of Anthony Mollica.
 – (top right) Anne Hébert. Photo by Editions du Seul (Paris, France), courtesy of Anthony Mollica.
 – (bottom left) Marie-Claire Blais. Photo courtesy of Anthony Mollica.
 – (bottom right) Gilles Vigneault. Photo by Birgit (Paris, France), courtesy of Anthony Mollica.
p. 32 – Georges Dor.

4 New Sound in the Land
p. 36 – French horn and bass violin players during rehearsal of the Toronto Symphony Orchestra. Photo by Chris Lund, courtesy of NFB Photothèque.
p. 38 – Gordon Lightfoot. Photo by Harold Whyte, courtesy of CBC Picture Service.
p. 41 – Mario Bernardi, conducting during rehearsal at the National Arts Centre, Ottawa. Photo by Crombie McNeill, courtesy of NFB Photothèque.
p. 44 – Mario Bernardi and the National Arts Centre orchestra during a performance, Ottawa. Photo by Crombie McNeill, courtesy of NFB Photothèque.
p. 47 – Maureen Forrester and Janis Orenstein in Menotti's *The Medium* at the Stratford Festival (1974). Directed by Michael Bawtree, designed by Susan Benson, musical direction by Raffi Armenian. Photo by Robert C. Ragsdale a.r.p.s., courtesy of the Ontario Arts Council.

5 The Problems of Success
p. 48 – An electrician working backstage at the O'Keefe Centre. Photo courtesy of the Ontario Arts Council.
p. 50 – Richard Partington and Denise Fergusson in Shakespeare's *A Midsummer Night's Dream* at the Stratford Festival (1976). Directed by Robin Phillips, designed by Susan Benson, music by Alan Laing. Photo by Robert C. Ragsdale a.r.p.s., courtesy of the Stratford Festival.
p. 52 – A scene from *Equus* at Le Théâtre du Nouveau Monde. Photo by André Le Coz, courtesy of the TNM.
p. 57 – Richard Monette in Michel Tremblay's *Hosanna* at the Tarragon Theatre. Photo by Robert A. Barnett.
p. 58 – Leon Major. Photo courtesy of Toronto Arts Productions.
p. 59 – John Hirsch. Photo courtesy of CBC Picture Service.
p. 60 – Paxton Whitehead in Bernard Shaw's *Arms and the Man* at the Shaw Festival, Niagara-on-the-Lake, Ont. (1976). Directed by Paxton Whitehead, sets and costumes by Maurice Strike. Photo by Robert C. Ragsdale a.r.p.s., courtesy of the Shaw Festival.
p. 61 – Kate Reid in Bernard Shaw's *Mrs. Warren's Profession* at the Shaw Festival, Niagara-on-the-Lake, Ont. (1976). Directed by Leslie Yeo, sets by Robert Winkler, costumes by Hilary Corbett. Photo by Robert C. Ragsdale a.r.p.s., courtesy of the Shaw Festival.
p. 63 – A scene from David Freeman's *Creeps*. Photo by Hugh Travers, courtesy of the Tarragon Theatre.
p. 64 – A scene from *St. Nicholas Hotel, The Donnellys, Part Two* at the Tarragon Theatre. Photo by Robert A. Barnett, courtesy of the Tarragon Theatre.
p. 65 – Alan Scarfe and August Schellenberg in George Ryga's *The Ecstasy of Rita Joe*, The Playhouse

Theatre Company of Vancouver, for the National Arts Centre's opening. Photo by Malcolm Perry, courtesy of CBC Picture Service.
p. 66 – A scene from *Leaving Home* by David French at the Tarragon Theatre. Photo by Robert A. Barnett, courtesy of the Tarragon Theatre.
p. 67 – Geordie Johnson, Bryan Foster, Bruce Bell and Bill Jackson in John Herbert's *Fortune and Men's Eyes* at the Phoenix Theatre. Directed by Graham Harley. Photo by Judy Whalen, courtesy of the Phoenix Theatre.

6 Make Way for Magic!
p. 68 – Inukshuk sculpture surrounded by rocks, Cape Dorset, N.W.T. Photo by Norman Hallendy, courtesy of NFB Photothèque.
p. 73 – (left) Lawren Harris: *Lake Superior Island* (1923). Oil on canvas. Photo courtesy of the McMichael Canadian Collection.
p. 73 – (right) A.Y. Jackson: *Houses, St. Urbain* (1934). Oil on panel. Photo courtesy of the McMichael Canadian Collection.
p. 74 – (left) A.Y. Jackson: *Above Lake Superior* (1924). Oil on canvas. Photo courtesy of the McMichael Canadian Collection.
p. 74 – (right) Lawren Harris: *Shimmering Water, Algonquin Park* (1922). Oil on canvas. Photo courtesy of the McMichael Canadian Collection.
p. 75 – (left) Tom Thomson: *Pine Island* (1914). Oil on panel. Photo courtesy of the McMichael Canadian Collection.
p. 75 – (right) F.H. Varley: *Stormy Weather, Georgian Bay* (1920). Oil on panel. Photo courtesy of the McMichael Canadian Collection.
p. 77 – Alfred Pellan. Photo by Marcel Cognac, courtesy of NFB Photothèque.
p. 78 – Ken Danby: *Opening the Gates* (1975). Egg tempera. Photo by T.E. Moore, courtesy of the Gallery Moos.
p. 80 – Emily Carr: *A Haida Village* (1930). Oil on canvas. Photo courtesy of the McMichael Canadian Collection.
p. 81 – Greg Cumoe: Detail from *Mariposa 10 Speed* (1973). Watercolour over graphite. Photo courtesy of The National Gallery of Canada, Ottawa.
p. 82 – (left) Rita Letendre: *Solagan* (1976). Photo by T.E. Moore, courtesy of the Gallery Moos.
p. 82 – (right) Robert Hedrick: *Magic Set* (1972). Bronze, unique cast. Photo courtesy of the Morris Gallery.
p. 83 – Armand Vaillancourt: untitled (1963). From the collection of the Musée d'art contemporain, Montréal. Photo from l'Office du Film du Québec.
p. 84 – Gerald Gladstone: *Universal Man* (1976). Cast bronze, at base of CN Tower, Arrivals Plaza. Photo of CN Tower.

7 Years of Crisis and Triumph
p. 86 – A scene from David Earle's *Operetta* danced by Toronto Dance Theatre members Barry Smith, Danny Grossman, Merle Salsberg, and Susan MacPherson. Photo courtesy of the Ontario Arts Council.
p. 88 – Dancers during a rehearsal of Les Grands Ballets Canadiens in Montréal. Photo by Pierre Gaudard, courtesy of NFB Photothèque.
p. 89 – A scene from *Tommy* with Steve Shocket, Camille, and Ted Neeley, at the O'Keefe Centre. Photo courtesy of the O'Keefe Centre.
p. 90 – Les Grands Ballets Canadiens. Photo by André Le Coz, courtesy of NFB Photothèque.
p. 91 – Ballet rehearsal. Photo by Pierre Gaudard, courtesy of NFB Photothèque.

p. 92 – National Ballet of Canada rehearsal of *Kettentanz* with Scott Barnard, Miguel Garcia, Mavis Staines, and Thomas Schramek. Photo courtesy of the Ontario Arts Council.
p. 95 – A scene from the National Ballet production of *The Sleeping Beauty* with Karen Kain and Frank Augustyn. Photo courtesy of the Ontario Arts Council.
p. 98 – The Royal Winnipeg Ballet about a decade ago, in a scene from Brian Macdonald's *Les Whoops-de-doo*. Music by Don Gillies. Photo courtesy of CBC Picture Service.

8 Flickering Shadows of Identity
p. 100 – Cameraman Michel Brault on location for Gilles Carle's *Kamouraska*. Photo by Bruno Massenet, courtesy of NFB Photothèque.
p. 103 – A scene from Claude Jutra's *Mon Oncle Antoine*. Photo courtesy of the National Film Archives.
p. 104 – A scene from Gilles Carle's *Red*. Photo courtesy of Consolidated Theatre Services.
p. 106 – A scene from Don Shebib's *Goin Down the Road*. Photo courtesy of Consolidated Theatre Services.
p. 107 – A scene from *Valérie*. Photo courtesy of the National Film Archives.
p. 108 – A scene from *Wedding in White*. Photo courtesy of Consolidated Theatre Services.
p. 110 – Chief Dan George. Photo courtesy of CBC Picture Service.
p. 112 – Two stills from Norman McLaren's *Pas de Deux*. Photos courtesy of the National Film Board.

9 The Soaring Cities
p. 114 – View of Habitat '67, Montréal. Photo by Faber, courtesy of NFB Photothèque.
p. 116 – View of Chateau Montebello, Québec. Photo courtesy of CP Hotels.
p. 117 – Looking down a street towards Notre Dame du Bonsecours church in Montréal. Photo by Chris Lund, courtesy of NFB Photothèque.
p. 119 – Exterior view of Toronto City Hall. Photo courtesy of NFB Photothèque.
p. 120 – Exterior view of an Erickson-designed house in British Columbia. Photo courtesy of *The Canadian Architect*.
p. 121 – View of the Erickson-designed University of Lethbridge. Photo by Simon Scott, courtesy of Arthur Erickson Architects, Vancouver.
p. 122 – View of the Thom-designed Trent University, Peterborough, Ontario. Photo by Benoni J. Truslow, courtesy of Trent University.

10 The Restless Air
p. 126 – Frank Willis, broadcasting from the scene of the Moose River disaster in 1936. Photo courtesy of CBC Picture Service.
p. 128 – On the set of Canada AM with hostess Helen Hutchinson and guest being prepared to go on the air. Photo courtesy of CTV.
p. 129 – Andrew Allan. Photo by Herb Nott & Co. Ltd., courtesy of CBC Picture Service.
p. 131 – Scene from *La Famille Plouffe*, with Rolland Bédard and the late Denise Pelletier. Photo courtesy of CBC Picture Service.
p. 132 – Johnny Wayne and Frank Shuster. Photo by Norman Chamberlin, courtesy of CBC Picture Service.
p. 134 – Barbara Frum. Photo by Harold Whyte, courtesy of CBC Picture Service.

Contents

Foreword

This book describes some of the ways Canadians express themselves through the arts. *The Arts in Canada* is an introduction for readers who are new to the subject, not an exhaustive survey. Some of the fields the book touches have already been the subjects of many volumes, and will be the subjects of many more; here we can only glance at them briefly, perhaps picking out a few facts and ideas of special interest to newcomers. I hope these words and ideas will stimulate curiosity and lead to wider reading. More important, I hope they will provoke you to investigate at first hand the original works of art we discuss and illustrate.

A newcomer to the country may find that in some of the arts – painting and poetry especially, but also film – the landscape plays an important role. This is because the immensity of the country impresses many of the artists and becomes one of the elements they want to describe and analyze. The more you know about Canada the more you sense the importance of the physical landscape.

Again, even a casual visitor to Canada must notice the prominence of native arts and crafts in the stores and museums. Among Canadians there are few forms of art more frequently bought and enjoyed than Inuit carvings, and in some parts of the country Indian crafts enjoy the same or greater popularity. This, too, reflects the nature of the country. Just a few hundred years ago, Inuit and Indians were the only humans here. Buying and owning their art is a way of having some relationship with their history and our own.

The arts, of course, can tell you a great deal about the ethnic make-up of a country. This book shows how that process works in Canada. In some chapters we deal with the products of French-speaking and English-speaking Canada together, because that is how they are normally seen. In painting, for instance, or in architecture, Canadians usually do not divide the two majority cultures into separate sections. But literature in Canada lives in separate French and English compartments, and therefore we deal with them separately.

In Canada, government plays a special role in the arts. All through this book you will find references to government agencies: the National Gallery, The Canada Council, the Canadian Film Development Corporation, the Canadian Broadcasting Corporation (Radio-Canada), The Canadian Radio-Television Commission. One reason for this is that in Canada government is the main patron of the arts. Through human history, the arts have always needed patrons: sales of art alone have seldom paid for cultural development. In many countries in Europe the arts in the past were heavily supported by royal or noble patrons. In Canada, in the past, there was little patronage of this kind and so there was only modest cultural development. In modern times, the government – acting for the public – has tried to provide the financial backing that the arts need.

Much of this activity stems from one public turning point at the beginning of the 1950s. After the Second World War Canada found itself in a situation of increasing material prosperity. But it was felt, particularly by some people in the government, that there were ways in which Canadians were not properly using the possibilities of the arts. In other countries governments were taking the lead in the arts – in Britain, for example, the Arts Council provided public funds to develop the arts. Should Canada have something similar? The federal government decided to address the issue through public discussion and inquiry. It appointed a leading diplomat and art patron, Vincent Massey, to head an investigation of these fields. The commission went across Canada, heard briefs, held public meetings in the ten provinces and collected reports from authorities like the writer Robertson Davies, the painter Charles Comfort, and the conductor Sir Ernest MacMillan.

The Massey Commission's recommendations – printed as the Royal Commission on National Development in the Arts, Letters and Sciences (1949-51) – focussed on three basic issues: (1) the need to make the arts more available to Canadians; (2) the need to provide financial backing for the arts; (3) the need to ensure that the arts can develop in

Canada independently of other countries, particularly the United States.

The Massey Report was criticized in some quarters, particularly by those people who had never thought Canadian cultural independence was of much importance. But it was widely accepted and it became the basis for cultural policy in our various governments during the next quarter of a century. The Massey Report said that Canada *needed* the arts, and moreover needed cultural forms that were independent. Down through the years various governments have done their best to satisfy these needs. How well they have satisfied them, of course, is a matter of personal opinion. On the one hand, the arts in Canada flourish now as they never have before and enormous progress has been made in making the arts available to as many citizens as possible. On the other hand, *mass* culture (which was a major concern of the Massey Commission) is still dominated in English Canada by the United States. At this writing there seems only a small chance that this will change during the twentieth century.

Certainly the Massey Commission – and all the events that flowed from it, including the establishment of The Canada Council – fundamentally changed the life of the artist in Canada. Today Canadian artists are not rich but they are frequently given the chance to do their work as they want to do it. In the course of doing it they find themselves again and again in a relationship with the government – or several governments.

These arrangements are complicated – sometimes even tangled – but they are necessary to make a cultural life possible in a country that is still, as the Massey Commission suggested, young and struggling to be itself.

The idea for this book originated in the Citizenship Branch of the Department of the Secretary of State. One of the purposes of the Citizenship Branch is to acquaint newcomers to Canada with the life and history of their new country. I hope this book will help to serve that purpose. I also hope that others, particularly young Canadians, will find it valuable as a first step toward an understanding of Canadian culture.

In the preparation of the text I was aided by two consultants: Sheila Fischman contributed the chapter on the literature of Québec, and Keith MacMillan collaborated with me on the chapter about music. I owe thanks to both of them, and thanks also to the officials of the Department of the Secretary of State for their encouragement and intelligent criticism.

Robert Fulford
Toronto

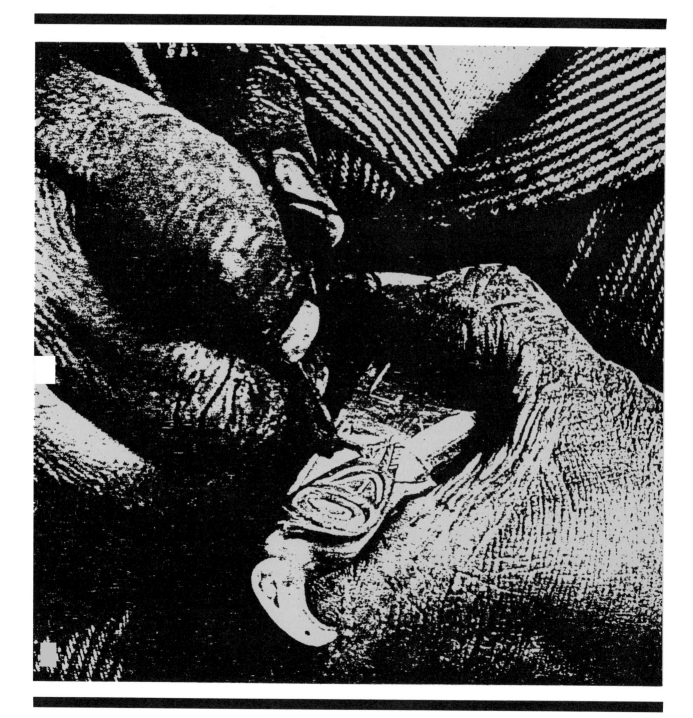

1 Beliefs and Hopes and Fears

The most striking quality common to all primitive art is its intense vitality. It is something made by people with a direct and immediate response to life. Sculpture and painting for them were not an activity of calculation or academicism, but a channel for expressing powerful beliefs, hopes and fears.

— Henry Moore

The eighteenth-century explorers who first landed on the Pacific coast of Canada reported that the Indian tribes they encountered—the Haidas, the Kwakiutls and the rest—had posts in front of their houses decorated with carved and painted designs. We have no record of what they looked like, but we can guess that these posts were the forerunners of one of the world's most spectacular art forms: the totem poles, those towering story-sculptures that expressed the spirit of West Coast Indian life for more than a century.

But the point is, the house posts were *not* totem poles. The totem poles came only after the white people had arrived. This is one of the most striking facts of primitive art: often it produces its finest and most impressive objects not when the primitive people are living by themselves in isolation, but when they are in touch (perhaps not too closely in touch) with invaders from more sophisticated cultures. Most of the Canadian Indian art we know, and most of the Canadian Inuit art we know, was made during periods of contact with whites, and very often the contact itself helped to produce the art.

The art of the Indians, both before and after the arrival of white people, is so rich and so diverse that even now, after decades of study, we are only beginning to understand it. There is no one kind of Indian art, just as there is no one kind of Indian. European settlers naturally found Indian art strange and exotic, but an Indian in eastern North America would have found the art of West Coast Indians equally strange. An Iroquois from the eastern forests, for instance, would have been as surprised by the sight of a totem pole as he was by his first glimpse of a sailing ship from France.

You can still see some of the totem poles of British Columbia—there are some in parks and museums, and there are still a few standing in Indian villages. But to grasp their significance you have to imagine an Indian river settlement in British Columbia a century ago, when the totem pole culture was at its peak. When you approached such a village you could see the poles from a distance, perhaps as many as thirty of

them, towering over the houses and the forest around. They would face out to the water, so that they would seem to greet you as you arrived. The carvings on the poles would be grotesque masks, painted in brilliant colours, showing the heads of frogs or fish or bears or whales, stacked one on top of each other. The effect was stunning. In the early years of this century, one of the greatest Canadian artists, Emily Carr, chose totem pole villages for the subjects of some of her best paintings.

Totem poles were not worshipped as idols, but the sculptures on them did reflect Indian beliefs in certain animal and natural spirits. Moreover, the West Coast Indian culture was a proud and materialistic one, and the totem poles were the great status symbols of the villages and the families, like cathedrals in medieval European towns or great office buildings in modern cities. The poles were also records of local history: often they would depict in symbolic form certain events in the past of a tribe or a village.

These almost incredible objects were the result of careful planning and dedicated work. Finding a cedar tree of sufficient height, then transporting it overland or by sea to wherever it was to be used, then carving it, then erecting it—this process sometimes took years. The carving process depended on European tools: the steel axe, the adze, and the curved knife, which the Indians acquired by trade from the Europeans and finally copied themselves. Just erecting the pole was a major project itself, given that the Indians had no construction equipment. There was considerable competition over the quality of carving—and even over the height of the pole.

This was a rich and competitive society.

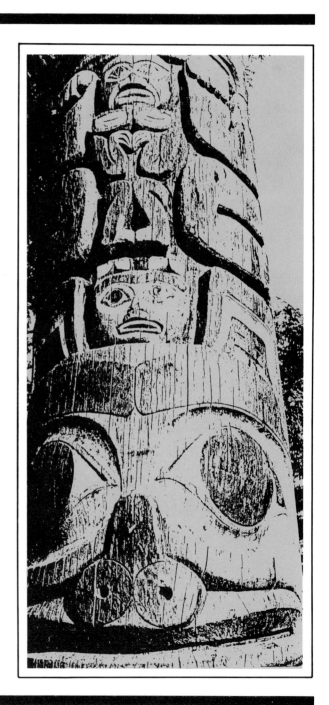

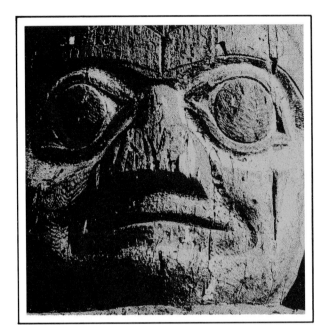

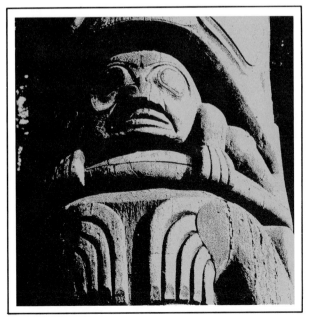

Nature provided a good climate and all the fish anyone might desire; the white people, after the 1780s, provided trade goods in return for fur. Marius Barbeau, a great scholar of early Canadian art, wrote:

> **The benefits accruing from the fur trade at once stimulated local ambitions; they stirred up jealousies and rivalries, and incited sustained efforts for higher prestige and leadership. The overmastering desire everywhere was to outdo the others in ingenuity and wealth, power and display.**

In the Nass River area of British Columbia there is a story that illustrates just how much these symbols meant to their communities. Hladerh, head-chief of the Wolves, announced that he would allow no one to erect a totem pole higher than his. Sispegoot, head-chief of the Killer Whales in the same village, let it be known that his was in fact to be taller, and he invited the village to the ceremony surrounding erection of the pole. As a result, Hladerh shot and wounded Sispegoot, and then later caused him to be murdered.

But not all the artistic and social passion of the West Coast Indians went into the totem poles. The same images and symbols that turned up on the totem poles also appeared on baskets and cups and plates. There were elaborate ceremonial masks used in dances, and magnificent costumes. A food ladle for a chief might be magnificently carved, and even a canoe paddle could be beautifully painted. Some of the styles, developed when the society was at its peak, are still

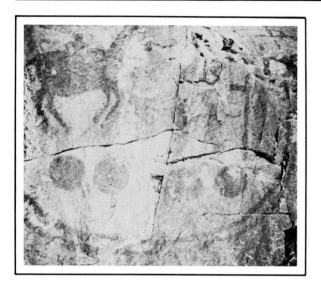

practised – there is a distinctive Haida style, for instance, which appeared in the nineteenth century and still can be seen in crafts and art objects produced by West Coast Indians today.

In those years of the totem pole culture the white people were close – but not too close. They came as occasional traders, not as conquerors or missionaries. Indian life went on, developing separately, sometimes at a headlong pace. The Indians still had their pride, and they had confidence in their own society. In the nineteenth century their art developed an unparalleled magnificence.

Eventually, though, white settlers moved in and dominated the land, and the Indians felt themselves pushed out to the margin. Their religion, too, suffered from this displacement. In some places totem poles were destroyed by Indians who had become Christians and who now saw the poles as part of their pagan past. A few whites, aware of the artistic value of the poles,

occasionally took steps to preserve them, but in many places the poles were forgotten. Like much Indian art, they are sadly impermanent. In the rain forests of British Columbia, often in totally deserted villages, the totem poles began, one by one, to fall to the ground and rot.

In modern times totem poles are still sometimes carved by Indians, but long ago they ceased to be at the centre of Indian life. William Reid, a modern Indian whose ancestors lived beneath the great cedar poles, wrote in 1971 about their fate:

> **Only a handful of poles now stand, or more frequently lie, in the damp, lush forests. Like the fallen trees they lie beside, they have become the life-blood of younger trees growing from their trunks.**

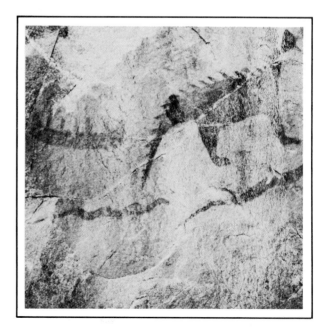

Once-great art thus returns to organic processes, and nature reclaims what was taken from it. A silence falls over the forest.

Much of the available art of Canadian Indians can be seen in the museums—or, as with totem poles, in certain parks. But there are other parts of the Indian heritage that must be sought out exactly where they were made—carvings on rock faces (called petroglyphs) and paintings on rock faces (called pictographs).

These are elusive art objects, and one of the problems with them is that even when you find them you cannot be sure exactly what you have found: often the meaning of the symbols they contain are lost in the mists of time. But they have special interest for two reasons. One is that the rock carvings may be the oldest evidence we have of Indian art—some may be thousands of years old, although dating them is usually impossible. The other is that, for imaginative people, seeing them exactly where they were made contains a certain beautiful mystery. Wilson Duff, an

anthropologist at the University of British Columbia, has described it this way:

> **With a little imagination, standing on the same lonely beaches where the ancient artists once stood, you can feel a kind of kinship with them. You cannot help but speculate on what they were trying to portray. The very mystery unfetters the imagination, and you think of solitary shamans (priests) imbued with visions of their spirit helpers and trying to record them at remote places of super-natural power, of secret societies, of cannibal spirits, perhaps even of sacrifices . . .**

This is art for the determined explorer. On the Pacific coast there are many Indian rock carv-

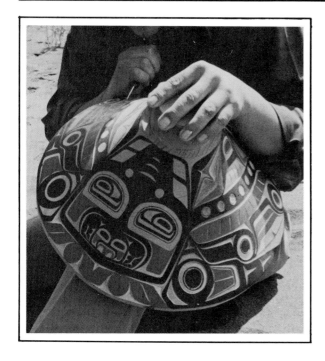

ings left over the centuries, but finding them is sometimes difficult. For instance, at Kulleet Bay, Ladysmith, on Vancouver Island, there is a tiny fascinating grove that was a secret site for ceremonies presided over by Indian shamans. The carvings are on a dried-up creek bed, on a sandstone shelf, and every available inch of the shelf has been carved on—sometimes carvings have been put over other carvings. The carvings show a shrimp, birds, a frog-man, and some mythical supernatural beings. So well hidden is the site that even today it is extremely hard to find it without the help of local Indians.

Sometimes the story of finding the art is almost as interesting as the art itself. At Agawa Bay in Ontario, on the north shore of Lake Superior, you can now walk up safe wooden

stairs and use a steel platform to see the Indian rock paintings: it is a first-class tourist site, complete with public lavatories. But for many decades the Agawa Site was unknown to any but a few and they kept it to themselves. Its discovery, in fact, was one of the more curious events in the history of Canadian archeology.

The existence of the Agawa Site was first recorded in 1851 by an American Indian agent named Henry Schoolcraft. He was stationed early in the nineteenth century in northern Michigan, and there he met an Indian shaman who told him about some fabulous rock paintings. Chingwauk, the shaman, told it in great detail, actually giving Schoolcraft a birchbark reproduction of the painting on the rock; Chingwauk drew it from memory. As Chingwauk described it, this great rock painting was put there by another shaman and it included paintings of fabulous creatures—like a serpent with two feet, armed with horns.

Schoolcraft never actually saw the Agawa Site, but through him it found a curious place in cultural history—Schoolcraft's friend, Henry Wadsworth Longfellow, used the Agawa symbols as a substantial part of his poem, *Hiawatha,* which became one of the most popular works of literature in North America for some decades. It contained passages based directly on Chingwauk's story, like this one:

> **Mitche Manito the Mighty,**
> **He the dreadful Spirit of Evil,**
> **As a serpent was depicted,**
> **As Kenabeek, the great serpent.**
> **Very crafty, very cunning,**
> **Is the Creeping Spirit of Evil**
> **Was the meaning of this symbol . . .**

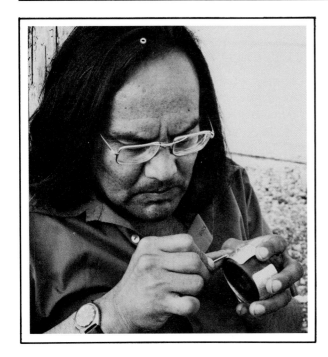

Schoolcraft also set down what he knew about Agawa—he called it Inscription Rock—in a book published in 1851. It was largely forgotten, however, for a century, and although a few people passed the Agawa site and some even painted their initials and the date on it ("K.D.1937") it was never written about and never—so far as is known—photographed. In 1957, however, a London, Ontario, artist named Selwyn Dewdney happened to read Schoolcraft's book. He was then looking for Indian rock paintings in Ontario, and he determined that he would find the one Schoolcraft wrote about—if it still existed. He began looking diligently, having found certain clues in what Schoolcraft wrote.

The next year he was there. As Dewdney and his party came to the shore of Agawa Bay, he looked up. "I stared. A huge animal with crested back and horned head. There was no mistaking him. And there, a man on a horse—and there four suns—and there, canoes. I felt the shivers coursing my back from nape to tail—the Schoolcraft site! Inscription Rock! My fourteen months' search was over."

No one knows when the magnificent rock paintings were made, and the explanation that Schoolcraft received from Chingwauk is still the only one we have. But two researchers, working in two different centuries, had done their work well. A piece of the past was reclaimed, for the benefit of the present and future.

Reclaiming the past is one of the major cultural efforts of this century. Today the best single collection of Indian art in Canada, and one of the best in the world, is at the National Museum of Man in Ottawa. How it got there tells us a great deal about what happened to Indian art, and how it was made, and how it was collected.

Indian art, first of all, was fragile. If it was made of wood, like the totem poles, then it rotted; often it was made of some delicate substance which could be destroyed when roughly handled. Some Indian tribes made extremely delicate designs in porcupine quills, exquisitely coloured; these often disintegrated.

More important, Indian art was neglected. Most of the white people who came to Canada in the beginning were absorbed in trade, religion or war—few had artistic interests. All around them the Indians, enriched by the fur trade, were making elaborately beautiful objects—but not many of the newcomers cared to notice. From the beginning, however, there were a few collectors, some

of whom sensed that back in Europe these curios of the New World would bring substantial prices. European curiosity about Indians was intense among the nobility, who began to make collections of artifacts from North America, sometimes comparing and exchanging curios with each other. Their castles contained cabinets of curiosities, which in the nineteenth century sometimes became public museums. Out in the New World there was no time for museums and there were few connoisseurs, so the Europeans became the keepers of the Indian heritage.

Arthur Speyer, Sr., who was born in Germany in 1894, the son of a professor of minerology, was a born collector. In his youth he began collecting outstanding art from all the primitive cultures, but after 1926 he focused his attention on North American Indian objects. These were so rare that they provided a special challenge, and over the years he added slowly and with great care to his collection. He made the collecting of these objects his life work: for instance, he would seek out every descendant that he could find of a famous traveller, in the hope that the traveller had left some important pieces to his family. He picked up Indian art once owned by the Duke of Saxe-Cobourg-Gotha, the King of Bavaria, the Duke of Wurttemberg, the Earl of Warwick, Sir Walter Scott, and many other famous collectors. Sometimes he found that European museums were not seriously interested in North American Indian art, and he acquired some of their pieces by trading African or Oceanic art that he had collected earlier. Meanwhile he was joined by his son, Arthur Speyer, Jr., who showed the same interests. Speyer, Sr. died in 1958 and his son carried on the tradition.

In many cases, the objects that the Speyers collected with such devotion were unique among world collections, or nearly unique. There was, for instance, the Naskapi Indian painted skin mat, a magnificent piece of craftsmanship created sometime before 1770 — a floor mat used in rituals held in honor of the game spirits. This was probably the only example of such an object in existence, except for some fragments in the Smithsonian Institution in Washington. The Speyers also found two examples of a long extinct type of Plains Cree woman's dress, which was until then known mainly from one example collected by Lewis and Clark on their expedition in 1805. The Speyers collected porcupine quill-work and sculpture in stone, weaving and beadwork, decorated furs and hair embroidery and perhaps a dozen other forms of Indian art.

When they were finished they had put together a uniquely rich collection of the many forms in which Indians expressed themselves, and by 1968 — when Arthur Speyer, Jr. was ready to show it publicly — the Speyer collection was the best in private hands in the world. Speyer put it briefly on public display in Germany, received the praise of experts who came from all over the world to see it, and then acknowledged that he was ready to part with it. After negotiations stretching over more than three years, the National Museum of Man acquired it: two hundred and fifty-nine objects of unparalleled richness, most of them from what is now Canada, most of them made between 1760 and 1850. They had, as a Museum of Man official put it, "come home".

Indian Art was trying to make another kind of comeback in the early 1970s. Canadian In-

dians themselves were trying to recover and re-create the skills and insights of their ancestors. Sometimes their efforts were meeting with remarkable success.

Indian artists for more than a century have felt stifled by white culture – and particularly white Christian culture. As the Europeans moved across North America they brought with them Christianity and Christianity's disbelief in other religions. This made Indian forms of religion suspect, and in some cases they were even outlawed. As a result, Indian art – which was so closely linked with religion – lost its meaning and in some places disappeared.

Tom Hills, a Seneca Indian from the Six Nations Reserve in Ontario, has put it this way: "The condemnation of the Indian's traditional spiritual life forced the artist to either forget his

talents or conform to prescribed artistic forms set by the white man. Consequently, the long and sacred traditions of Canada's indigenous artists ebbed to an unforgivable low as they passively accepted the Victorian aesthetic tastes, their culture and their established order." But there is evidence now that this process is being slowly reversed.

Consider the situation at Hazelton in the interior of northern British Columbia. There the cultural traditions go back a full five thousand years. The Gitksan and Hagwilget Carrier peoples, speaking an Athapaskan language, had until a few decades ago a rich visual culture based on ceremony. Their lodges, poles and ceremonial garments were collected all over the world. But as Dr. George MacDonald, of the National Museums of Canada, has written:

> **...this ancient tradition came precariously close to extinction, and may not yet be beyond danger. The master carvers of the Gitksan had died off without heirs, and only the very old could remember many of the dances and songs. Totems orginally carved for special festivities in the villages were slowly decaying, with no new ones to take their place...**

But that particular Indian culture, one of hundreds, turned out to be in a coma rather than altogether dead. In the 1960s the local people, whites as well as Indians, began to make efforts to restore it—to bring back both the visual arts and the ceremonies for which they were often made.

The project—called 'KSAN—began as a way to solve the area's economic problems.

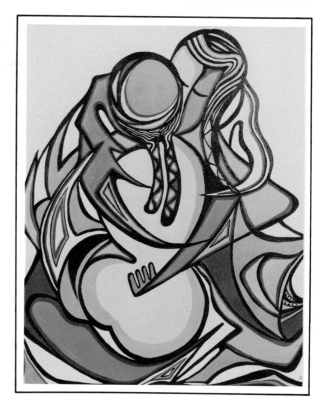

Some of the members of the Hazelton Library Association conceived the idea of building an Indian village as it might have existed a century before. They assembled funds from local, provincial and federal governments, collected whatever art was available, and created a series of buildings to house it. More important, they began to encourage local people to explore the possibilities of their artistic tradition. They scoured museums for examples of their ancestors' art and brought in, as teachers, expert Northwest Coast Indian artists. By 1970 they were able to open their village.

An Indian song of the area contains the words: "Walk on, walk on, walk on, on the

breath of our grandfathers.'' That breath, miraculously, came back to the artists of 'KSAN. The art they began to produce was very close, in quality, to the art of a century ago preserved in museums. Sometimes the artists began by copying old sculptures and then developed their own designs in the same tradition—masks, hats, beaded robes, totem poles, elaborately decorated boxes. The art began to be exhibited widely. At the same time, other Indians became performing artists, and—acting on advice obtained from the old men and women of the area—revived the dances and ceremonies of ancient times. Now a visitor can go to 'KSAN and obtain some idea of

what Indian life was like long ago. As Dr. MacDonald has written:

> **Many thousands of visitors to 'KSAN have carried away with them startling, dramatic memories of the thunder of the box drum in the feast house, the shadows and reflections of masked dancers miming the movements of the raven and the eagle, the grizzly bear and mountain goat, the killer whale and the frog. More and more, 'KSAN is becoming a total artistic environment.**

'KSAN is a successful collective attempt to revive Indian art. But there are also, across Canada, many individual attempts that are in their own way just as successful. William Reid, for instance, is known across the country for the jewellery he makes in his studio in Montréal. Reid is of Haida descent, but like many Indians of his generation he did not acquire his skills from his immediate ancestors. Instead he found them in museums and textbooks. Nevertheless, his art—often rendered in the traditional argillite, a slate-like material found in the Queen Charlotte Islands in British Columbia—is unmistakably Indian in origin.

Indian painters who came to maturity in the 1960s found themselves between two traditions: the modern art tradition as expressed in the big-city art galleries, and whatever Indian tradition remained at home. The best of them drew strength from both of these traditions and began to create individual artistic personalities that were both "modern" and Indian.

For instance, Alex Janvier, a Chipewyan

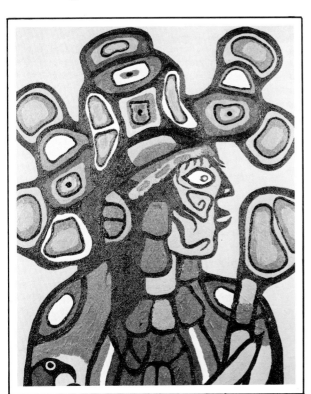

who has recently worked in Edmonton, paints completely abstract non-representational pictures in which the shapes and colours are distinctly Indian. Daphne Odjig, an Odawa painter, creates canvasses that use Indian myth and Indian legend in distinctly contemporary ways.

The most famous of these artists is Norval Morrisseau, a self-taught Ojibway. His paintings, done in acrylic on rough brown paper, have a primitive quality that appeals to many collectors. (In 1962 he had an exhibition at the Pollock Gallery in Toronto and sold out every painting in the first twenty-four hours.) Morrisseau's work freely re-interprets ancient Indian legends and symbols.

His success broke new ground for Indian artists: he proved it was possible to express Indian ideas and also find acceptance in the modern art world. A great many other artists have followed after him and today there is a whole new generation of Indian artists in Canada.

There is an Inuit print called *Sea Monsters Devouring Whale* which was made in 1961 by a man named Kiakshuk. It shows gigantic mythological creatures from beneath the ocean tearing a whale apart and swallowing it. The print is vivid and dramatic, and the fact that it exists at all is one of the wonders of Inuit culture.

The man who made it was old; he died four years later. When he grew up there was no such thing as "Eskimo art" or, as it is called today, "Inuit art", known to the world—merely some stone carvings done by people like him, occasionally, for their own use. Their art wasn't art at all, in the sense we understand the word. For instance, the sculptures they made—of seals or fish or bears or whatever—were never placed in one position on a shelf but were kept in the pockets of one's coat and then passed around occasionally for inspection. In the money sense they were worthless, though they might be prized by their owners. At one time, of course, there was no printing on paper among the Inuit. The only economy Kiakshuk knew as a young man was the economy of hunting.

In some parts of the Inuit world, carving was nearly as common as hunting. When the anthropologist Edmund Carpenter visited the Aivilik people on Southampton Island in the early 1950s he reported: "Every adult Aivilik is an accomplished ivory carver: carving is a normal, essential requirement, just as writing is with us. Some are better carvers than others, just as some of us are better penmen than others. And carving is done for a purpose, just as writing is with us. The carver doesn't divide his products into works of art and utilitarian objects, but the two are usually one: the sun goggles are beautiful . . . the harpoon is graceful . . . "

But not all Aivilik carving was for purposes of everyday use. The Aivilik also sometimes carved for magic purposes—for instance, they believed if they carved a seal then a seal might come and they could hunt it. Sometimes they made carvings like this and then set them aside or forgot them entirely. "Art to the Aivilik is an act, not an object, a ritual not a possession," wrote Carpenter.

That was, in a way, the kind of world Kiakshuk must have known when he was young. But all that changed. Inuit art became a cult among many white people outside. Money from the south flowed into the Arctic and thousands of carvings flowed out. In the Canadian Arctic there

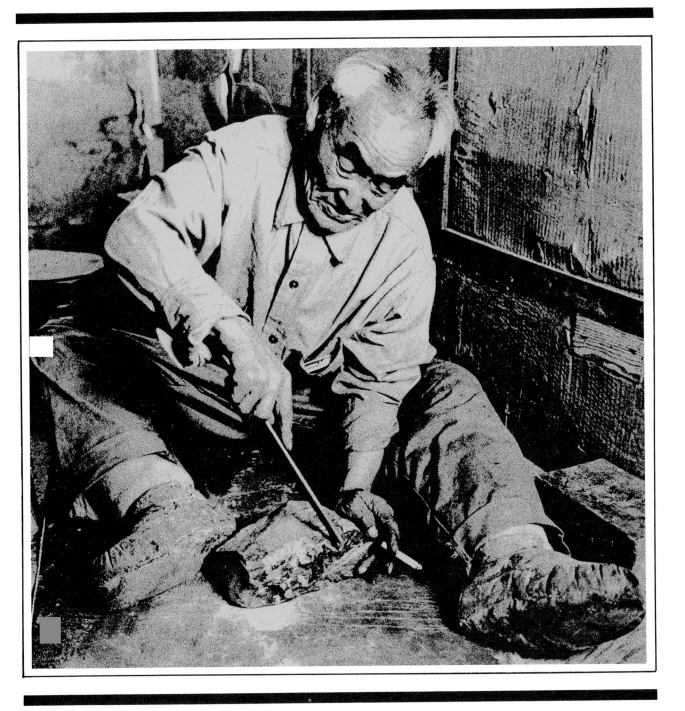

are only 30 000 Inuit—only enough people to fill a street of apartment buildings in a big city like Vancouver or Montréal—but they produced a unique art form that impressed itself on the people of Canada and on people in many other parts of the world.

As more people outside the Arctic became interested in Inuit art, it changed. For one thing, there came to be much more of it—Inuit who had previously made only occasional carvings now gave much more time to it. Now they put bases on their carvings, so that collectors in the south could stand them on their mantels. Some carvers were corrupted by the attention and began to produce repetitious art that was good only for the most naive buyers.

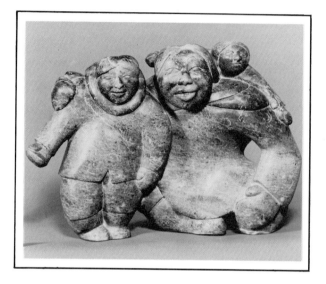

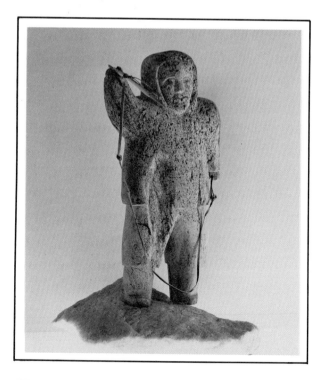

And then something else happened. The same people who had encouraged the Inuit to carve more decided to encourage them in an art form new to them: print-making. An expert artist went to Japan to learn certain print-making techniques and then took them into the Arctic. Miraculously, the prints that the Inuit produced were almost as well received as their sculpture. Inuit prints began to appear in art galleries, in fashionable living rooms, in magazines, on Christmas cards. They, too, quickly became a part of Canadian life.

So it was that Kiakshuk, who grew up when none of this had happened, lived long enough to become a professional artist, to have his works sold in art galleries and reproduced in books, to be looked at thousands of miles away from the white desolation in which he existed all his life. But at the end, when he was in the middle of this art explosion, he remained still an Inuit and though the form of his art was strange the content

grew out of his life and his history and his beliefs.

James Houston, the great mentor of Inuit art, wrote about Kiakshuk in this way:

> **Kiakshuk died in 1965, an old man who had seen many changes in his life. He had been raised to the mask and drum of shamanism [Inuit religion], governed by a vast world of spirits. His world had then encompassed the space age and a time when someone he had never seen wished to have his ideas marked on sheets of snow-white paper. He would sometimes laugh and quickly look behind himself, for he could not believe that there was real safety in changing times.**

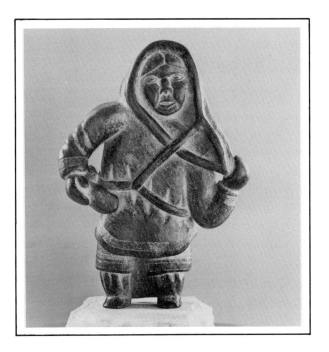

There is indeed no safety in changing times, but the twentieth century has been a time of unceasing change for the Inuit and their art has reflected those changes in many surprising ways. The twentieth century brought to the Arctic first the fur traders, then the miners and prospectors and men looking for oil, and with them the government officials in great numbers. In the twentieth century it was discovered that the land inhabited by the Inuit was fabulously wealthy in minerals and oils, and since that territory was part of Canada the southern Canadians felt called upon to explore and exploit it. In the course of this activity they disrupted the Inuit way of life.

Commercial art was part of that disruption. James Houston was a young artist when in 1948 he first went to Canso Bay on the far northeastern section of Hudson Bay. There Houston was given a small soapstone carving in exchange for a drawing he had made of an Inuit. When he received it he guessed that it might be one of many, and before he returned to the south he acquired a few more. It occurred to him then that the Inuit might profit financially by their art. They were living from hunting animals and selling the skins, but their life was poor. He determined to do something about it.

When he returned to the south Houston went to the Canadian Handicrafts Guild in Montréal. Inuit carvings were known to many people then, of course – traders and others in the north had collected them, and some were in museums. In fact, some collected Inuit art was as much as 2 800 years old. But the carvings were not sold methodically, and they were not sold in great numbers. Houston pointed out that there must be many more carvings like the one he had

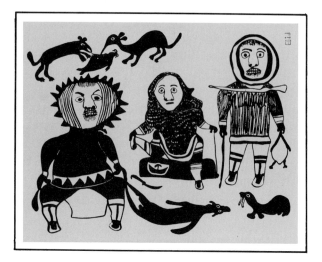

found, and he convinced the Canadian Handi-crafts Guild that it should back him. The next summer he went north again to buy carvings from the Inuit at Port Harrison.

As Houston told the story later:

During the trip, about a thousand ar-ticles were bought, and were ar-ranged for a November sale at the Peel Street shop of the Canadian Handicrafts Guild in Montréal. The Guild advertised the sale, scheduled to last a week. It was over, however, in three days. All the articles had been sold!

Later the federal government offered as-sistance to Houston, and eventually he became a civil administrator for the government in Baffin Island. He continued to collect the carvings and arrange for their sale. By 1952, after only four years of activity, he reported that more than 20 000 Inuit pieces had been purchased. Inuit art

was an industry. But: "The Inuit's desire for origi-nality is clearly illustrated in that of all these, no two are really alike." Later it was Houston who pushed Inuit art to the next stage by introducing print-making and helping to set up co-operative workshops in the Arctic where Inuit, under their own control and management, produced art for sale in the south.

This process led to many surprises for people who felt they understood primitive art. In the 1950s, as Inuit art grew more popular and many Inuit consciously made carvings for the trade in the south, experts predicted the art would soon be ruined. White values were imposed on the North, and this—it was widely believed—could only lead to disaster for the art of the Inuit, in a very few years.

Instead Inuit art flourished. It changed enormously, but in some ways it changed for the better. In the 1960s and the 1970s the Arctic produced new generations of carvers who learned something of the white people's art and

put that learning to advantage. They produced much larger pieces, for instance, and in many cases these massive objects were excellent sculpture. George Swinton of the University of Manitoba, one of the great experts on Inuit art, confessed in 1972 that he and his fellow experts had been entirely wrong. "Little did we know about the nature of [Inuit] culture," Swinton wrote. What they didn't know was that the Inuit were infinitely adaptable. They could change in many ways under many different forms of pressure, but in the process they could remain Inuit. The very adversities presented by the invasion of white people acted on them as a challenge and a stimulus. By the 1970s some of the best and most serious artists in Canada were Inuit, and their work continued to be received with enthusiasm in the cities of the south. "Contemporary [Inuit] art," George Swinton wrote, "has indeed become a new art form. It is the art of the new [Inuit]. That [Inuit] is still in the process of change. So is his art."

In 1971 the government of Canada and the Canadian Eskimo Arts Council arranged the greatest exhibition of Inuit art ever held, called "Sculpture/Inuit." It went to museums in Moscow, Leningrad, Copenhagen, Paris, London, Philadelphia, Ottawa, Vancouver and Montréal, and everywhere it drew enthusiastic crowds and excited reactions in the newspapers. In the catalogue of that exhibition James Houston wrote:

The Metropolitan Museum of Art in New York in a recent exhibition, Masterpieces of Fifty Centuries, showed three contemporary Canadian sculptures. They were displayed along with the great works of Egyptian tomb builders and Greek Temple makers, Leonardo da Vinci and Rembrandt, Hokusai and Picasso. It was a heartwarming sight to view these three stone carvings of the Arctic, a sea goddess, a seated woman with child, and a wild green bear, all resting in timeless harmony with so many other works of genius.

2 Stories Out There

There's a story out there boys Canada could you bear some folk songs about freedom and death
— Leonard Cohen, 1964

A country's literature can tell its story even when the people who write the literature don't set out to do so. Few writers anywhere ever said: My books will tell what my country is like. Certainly few Canadian writers have said that—many of them have hoped to be read mainly *outside* Canada, and some have gone so far as to avoid Canadian place names in their books.

And yet, when you read the books of Canada, and in some cases look at the careers of our writers, you may learn more about Canadian life than you can learn from any political history. Almost accidentally, the writers create in their books a sense of the country's style of life.

People who come to Canada from other places don't expect to find that novelists and poets are prominent on the Canadian scene. Newcomers may have heard of Mazo de la Roche or Leonard Cohen (depending on what genera-

tion the newcomers belong to), but they won't know about many others. Canadian literature has not become celebrated around the world.

Perhaps this is because Canadians, for a long time, were too busy building their country to find time for literature. But Canada now has a flourishing literary community, steadily increasing in size and influence. There are hundreds of men and women across the country who call themselves professional poets or novelists. Their work is read by growing numbers of Canadians.

Each university contains its group of poets, and in some there are courses in creative writing. Public poetry readings, once rare in Canada, are now a regular part of campus life. Across the country, in the English language alone, there are more than sixty independent Canadian-owned publishers (some are tiny operations, run on a part-time or amateur basis). There are branch offices of American and British publishing companies, some of which issue Canadian books as well as importing books from their home offices. Most universities and many high schools now offer courses in Canadian literature—courses which did not exist ten years ago.

The geographic focus of English-Canadian literary life is Toronto. In literature, as in many other aspects of Canadian life, Toronto works like a market town in a rural community. Even if a writer never lives there, he goes there eventually to sell his work. Many of our magazines are published in Toronto, and most book publishers have offices there. Other people who buy writers' work, such as the Canadian Broadcasting Corporation, maintain their offices in Toronto. Hence many of the best writers live in Toronto.

Morley Callaghan, for instance. Callaghan

is perhaps the most widely respected figure in English-Canadian writing: since the 1920s he has been writing important novels and stories, and these have been published around the world in many languages. He lives and works in Rosedale, an old, tree-lined, residential section within the city.

Within the city, too, is the University of Toronto, where dozens of books are written each year. On the campus itself there are three men who are important literary figures around the English-speaking world. Robertson Davies, whose novels are widely praised in the United States and Britain as well as in Canada, is Master of Massey College. Northrop Frye, one of the most important literary critics anywhere in the world, is a university professor. Marshall Mc-Luhan, whose theories on communications revolutionized thinking around the world in the 1960s, directs a small research institute.

Toronto contains the most popular writer now living in English Canada: Pierre Berton. His books sometimes sell as many as 100 000 copies, and by looking at them – and at the way we respond to them – you can understand certain important facts about Canada.

Berton was born in the Yukon Territory in the Canadian Northwest, in 1920. He was brought up in Dawson City, the son of a man who went there in 1898 to seek his fortune in the Klondike gold rush.

Berton was a newspaperman in Vancouver in the 1940s, then a magazine editor in Toronto in the 1950s. In the late 1950s he became best known as a television personality – he is still most famous in that role – but at the same time he was beginning a series of books that were to be among the most important popular books of his time.

In 1956 Berton wrote *The Mysterious North*, a book about the history and possibilities of development in the Canadian North. This book reflected the mood of the times, which was confident and largely unquestioning about the future. Canadians in the 1950s were developing their society faster than at any time in the past, and they were becoming aware of what lay ahead in the North. We were just beginning to imagine that our real future might be there.

In 1958 Berton returned to the scenes of his boyhood in Dawson and wrote *Klondike: The Life and Death of the Last Great Goldrush*. In the early 1970s he published his two most popular books, *The National Dream* and *The Last Spike*,

about the building of the Canadian Pacific Railroad, the most momentous development in the creation of the Canadian nation in the nineteenth century. Berton has written many other books, including a famous one, *The Comfortable Pew*, about complacency in the Christian churches. But the great theme of his life is the western and northern development of Canada, and the stories of the men and women who took part in that development.

When Berton was growing up he was surrounded by history: Dawson was a kind of ghost town, filled with the stories of the old-timers who have lived in the Klondike. This is where he acquired his taste for the drama of the past. At the end of *The Last Spike* he describes the scene in 1885 after the great railroad was completed, the last spike being driven at Craigellachie in the mountains of British Columbia:

> **Then the locomotive whistle sounded again and a voice was heard to cry: 'All aboard for the Pacific.' It was the first time that phrase had been used by a conductor from the East... The official party obediently boarded the cars and a few moments later the little train was in motion again, clattering over the newly laid rail and over the last spike and down the long incline of the mountains, off towards the dark canyon of the Fraser, off to the broad meadows beyond, off to the blue Pacific and into history.**

The romanticism of Berton's writing touches a nerve in modern Canadians. Most of us were brought up to believe that our history is dull,

but in recent years writers like Berton have tried hard—and successfully—to tell us otherwise. "There's a story out there boys," Leonard Cohen wrote. Berton is one of those who tell it. The response to his work proves that Canadians want to hear it.

The novelists of Canada don't set out, so consciously, to describe the Canadian situation. But the life of our times comes through in their books anyway—and comes through in their careers as well. Mordecai Richler, who was born in Montréal in 1931, is the most popular and

most praised novelist of his generation. His books show in interesting ways a slowly growing consciousness of Canadian life.

His second novel, *Son of a Smaller Hero*, published in 1954, is a typical young man's novel in one way: it reflects father-son conflicts, and a young man's striving for a place in the larger world. But it surprised many Canadians when it appeared because it revealed to them the existence of a Montréal Jewish ghetto they knew little about. It described the ghetto of the 1940s and the 1950s in passages like this:

All day long St. Lawrence Boulevard, or Main Street, is a frenzy of poor Jews, who gather there to buy groceries, furniture, clothing and meat. Most walls are plastered with fraying election bills, in Yiddish, French and English. The street reeks of garlic and quarrels and bill collectors: orange crates, stuffed full with garbage and decaying fruit, are piled slipshod in most alleys. Swift children gobble pilfered plums, slower cats prowl the fish market. After the water truck has passed, the odd dead rat can be seen floating down the gutter followed fast by rotten apples, cigar butts, chunks of horse manure and a terrifying zigzag of flies. Few stores go in for posh window displays. Instead, their windows are jammed full and pasted up with streamers that say ALL GOODS REDUCED or EVERYTHING MUST GO.

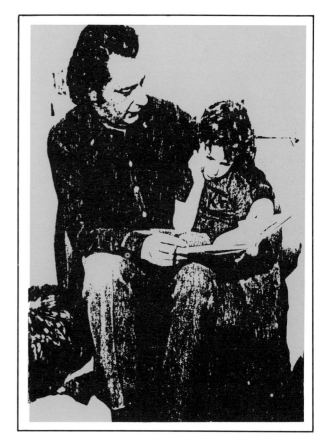

Son of a Smaller Hero was not a great public success, but it announced the arrival of a writer who had a great deal to say and could say it well. In later books Richler played on similar themes. *The Apprenticeship of Duddy Kravitz*, which was published in 1959 and filmed in 1973, is the story of a young man growing up in the Montréal ghetto and then seeking to reach beyond. Its pages are crammed with a sense of the life of Montréal and its racial character—Jews, Anglo-Saxons, and French Canadians reacting to each other as they struggle to build their lives. *Duddy Kravitz* is now considered one of the classics of modern Canadian literature.

Richler continued to expand and develop his account of Canadian society. *The Incomparable Atuk*, published in 1963, is a satire on Toronto cultural life and its pretentions: there is a heavy emphasis on Canadian cultural nationalism. *St. Urbain's Horseman*, published in 1971, is about a Canadian film and theatre director who lives a large part of his life in England, as Richler himself did. It reveals a great deal about the feelings of Richler's generation of Canadians toward their own country—a mixture of pride, boredom and hope.

When he was twenty-six years old Richler

said in an interview: "All my attitudes are Canadian. I'm a Canadian; there's nothing to be done about it." For Richler's generation this was a common theme: Canada was seen as a cross to be borne rather than a flag to be waved. Canadian artists resigned themselves to the fact that Canada itself was dull and prosaic and Canadians were not interested in what might be written about them. Many of these artists followed their careers abroad, as Richler did; he lived for about two decades in England.

He became a part of international literature. He read, and was influenced by, the American Jewish novelists of the 1950s and the 1960s, and modern English literature also played a large part in his life. The hero of *Cocksure*, his satiric novel published in 1968, is an innocent young Canadian baffled by the sensation-hungry world of swinging London in the 1960s. Richler, like many of his generation, found Canadian nationalism repugnant, and the Canadian scene somewhat too tightly enclosed. But by reading his books you could learn a great deal about what Canadians were thinking and feeling.

You could learn a great deal, too, from the poems and novels of Leonard Cohen. Like Richler, Cohen came out of Montréal Jewry; but in most other ways they were entirely different. Richler came from the poor ghetto, Cohen from an affluent background in the rich Westmount community. Richler reflected the social concerns of American fiction, Cohen came out of the Montréal poetry movement which had first brought international poetic forms to Canada in the 1930s. They were born only three years apart (Cohen in 1934), but they seemed to be from different generations. Where Richler scorned or satirized the world of 1960s pop culture, Cohen joined it—he became famous as a singer on records and in concert performances. Where Richler tended to keep his personal life private, Cohen tended to expose his—often his poems and songs told of his lost loves and his feelings of weakness.

When Cohen wrote in 1964 "Canada could you bear some folk songs about freedom and death", he was in effect asking whether Canadians could stand to have the real world described to them. Like many of his generation, Cohen saw the Canadian literature that came before him as too tame and conservative. Cohen's work, by contrast, was daring and challenging.

Poems! break out!
break my head!

he once wrote. Among all the writers of modern Canada, he is the one who most publicly lives the traditional romantic life, the life of excess. A character in one of his novels states: "Women love excess in a man because it separates him from his fellows and makes him lonely. All that women know of the male world has been revealed to them by lonely, excessive refugees from it."

As Cohen saw it, his mission was to bring not only erotic frankness to Canadian poetry but also terror, madness and death, the recurrent themes of experimental literature in Europe and America. Cohen's poems have dealt with murder, betrayal, the pogroms, the Nazi death camps and the whole beautiful and terrible history of the Jews.

In the 1960s Cohen wrote two novels, *The Favourite Game* and *Beautiful Losers*. The first is a semi-autobiographical novel about the loves of a young man in Montréal. The second is a kind of

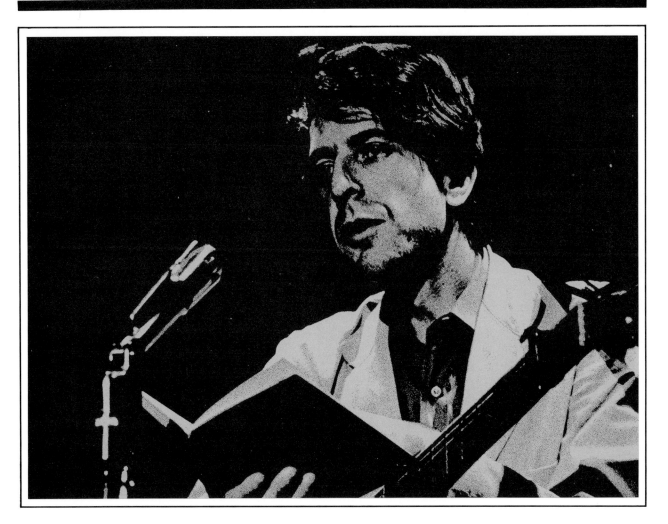

nightmare-novel, a series of fantasies dealing with everything from bisexual love to Adolf Hitler. At the centre of the book is a fantasy about a real historical figure, Catherine Tekakwitha, an Iroquois virgin and martyr, who died a Christian in 1680 and became the first Indian venerated by the Roman Catholic Church. The book sets her story against the thoughts and actions of several modern intellectuals, one of whom is involved in Québec separatism.

Cohen resembles Richler in one important way: though he has often lived outside Canada and has acquired an international reputation, Canadian themes play a major role in his work. Cohen lived for many years in Greece, and in the early 1970s his professional life took place mainly

in the United States. But in *Beautiful Losers*, as in many of his poems, he tries to come to grips with the Canadian experience. An English critic and novelist, John Wain, wrote about *Beautiful Losers*: "Mr. Cohen has a real theme, the frightening vacuum of modern Canada and the Canadian's uncertainty as to who he is and where his allegiances lie, both historically and in the present."

Cohen and Richler are internationalists with firm Canadian roots. So is Margaret Laurence, another major writer who reached prominence in the 1960s. Her work, however, is clearly split between foreign and Canadian backgrounds. She has lived much of her adult life abroad, in Somalia, Ghana and England. She has written a novel, a book of stories and a travel book about Africa, and all of these have achieved some success. But her most widely admired writing is linked closely to the place she began her life—Neepawa, Manitoba, a little town about one hundred and twenty-five miles northwest of Winnipeg.

It was there she was born (in 1926), there she grew up, there she formed her earliest and most lasting impressions about human relations, and there she came to see herself as a writer. As a child of twelve she wrote a novel, about Canadian pioneers. Other children may write of faraway places they imagine to be exciting. Margaret Laurence knew from the beginning what her great subject was to be: the life she saw around her.

The town of Neepawa appears in her novels and short stories as Manawaka. Hagar Shipley lives there in *The Stone Angel* (1964), Rachel Cameron lives there in *A Jest of God* (1966), Stacey Cameron has come from there in *The Fire Dwellers* (1969) and Vanessa MacLeod

grows up there in *A Bird in the House* (1970). Each of these books draws the reader into the prairie experience as Margaret Laurence observed and imagined it, but the one that has affected readers most deeply is *The Stone Angel*. Its central figure, Hagar, is a proud woman of ninety, living her last days with her son and daughter-in-law in Vancouver. The novel explores what her life has been and what she has made of it. It explores the western society Hagar has lived through, and the physical setting of her life as lived in hard times:

The prairie had a hushed look. Rippled dust lay across the fields. The square frame houses squatted exposed, drabber than before, and some of the windows were boarded over like bandaged eyes. Barbed-wire fences had tippled flimsily and not been set to rights. The Russian thistle flourished, emblem of want, and farmers cut it and fed it to their lean cattle. The crows still cawed, and overhead the telephone wires still twanged all up and down the washboard roads. Yet nothing was the same at all.

The wind was everywhere, shuffling through the dust, wading and stirring until the air was thickly grey with grit. John met me at the station. He had an old car, but he wasn't using its engine. It was hitched to a horse. He saw my astounded stare.

'Gas is expensive.'

The world-wide economic Depression of the 1930s hit Western Canada with special force and came at the same time as drought and crop failures. Many writers have tried to describe it, but few have done it so well as Margaret Laurence in those few paragraphs. She once said: "What I care about . . . is to express something that in fact everybody knows, but doesn't say." Her books are never flamboyant or romantic. They deal with the most crucial emotions and events in human lives—birth, death, the sense of loss when something important is taken away. But always these things are handled with a straightforward honesty that makes them humanly manageable. Margaret Laurence makes mundane life crackle with poetic intensity. Her songs, like Cohen's, are about freedom and death.

Berton, Richler, Cohen and Laurence stand for four distinct ways of absorbing the Canadian experience and turning it into literature. They began their careers at a time when to declare yourself a Canadian writer was a daring act—the profession of writing was hardly established in this country, and earning your living by writing books was only a distant possibility. Now each is an established figure with a sizeable body of work in the past. They are all middle-aged or close to it. By creating their own careers they have helped to create a profession of letters in Canada. But what of the writers who follow them?

There are at least two more generations of Canadian writers already, and these men and women differ in important ways. For one thing, they are far more numerous—it seems quite natural now for university students to state that their profession will be literature, and many more do so. For another thing, they are more self-consciously Canadian—nationalism has deep roots among the new writers of English-speaking Canada. For still another, they are more involved with the act of publishing itself—unlike Richler or Cohen, they often set up as publishers themselves, founding small independent houses. They think of themselves not only as writers about Canada but as writers *for* Canada—they believe their main audience will be found here rather than in the United States or Britain.

At the same time, there's a reaction, particularly among the poets, to the dominance of the great cities. A generation ago it was accepted

that culture and big cities were mutually necessary: if you wanted to participate in the artistic life of Canada you moved to one of the big cities. Culture was seen as something spreading out from the cities, and the small towns and rural areas were (if involved at all) on the receiving end. But in the late 1960s artists' views on this point changed. They began to see the values of what came to be called "regionalism" and their poetry reflected the new attitude. Alden Nowlan in New Brunswick, Patrick Lane in the interior of British Columbia, Sid Marty in rural Alberta—they all speak clearly in their poetry of life in their own regions; and so do a hundred other poets publishing across Canada. For many of them the poet Al Purdy of Ameliasburg, Ontario, serves as a kind of mentor. He brings to his poetry an appreciation of Canadian diversity; to read him is to sense the peculiar and fascinating form that Canadian nationalism has taken in the last eight or ten years—a love for (and celebration of) the specific regions of the country.

The typical young Canadian writer of the 1970s, if there is one, lives a life different from the life Richler and the others lived in their twenties. He is closely involved with government, and so—probably—is his publisher (or the publishing house he may partly own). The theatre is now open to her if she chooses to write a play, and Canadian filmmakers may want her to write scripts. If he writes poems there are many chances to read them in public. If she cares for the academic life she may become a writer-in-residence at one of the universities. She will not be surprised if the students she meets are studying her own work.

When they face their typewriters they are still lonely individuals, working by themselves to turn their own private visions into words on paper. But now they are also part of a large literary community, linked in many ways with the country as a whole. Canadian writers in this age are an accepted and essential part of the society.

3 Life to be Discovered

We don't have an identity until someone writes about us; the fiction makes us real.

—*Robert Kroetsch*

Our country is at the age of the first days of the world. Life here is ready to be discovered, to be named.

— *Anne Hébert*

The first sentence, by an English-Canadian novelist who lives in the United States, applies to any country, any society, any individual or group of people in the world. Including French Canada. The second statement, by one of French Canada's most distinguished and best known poets and novelists (who lives in France), is perhaps more closely related to the present state of affairs in French Canada, in Québec.

For three centuries Québec has been moving towards a definition of its identity, an identity that its writers have been in the process of making real. Since 1960 or so the identity has been established and enunciated with increasing clarity, and it has a growing variety and number of voices.

1960 might be considered a starting point for the new cultural awareness in Québec. There was an important change of government, the province's education system was the subject of an official study, and an unknown teaching brother who was eventually named Frère Untel (Brother Anonymous) wrote a letter to the Montréal newspaper *Le Devoir* deploring the kind of French spoken by young people in the province. He coined a name for this language, "joual," from the way he heard these young people pronounce "cheval," horse. Frère Untel went on to publish an angry but witty book and all French Canada, later the entire country, was made aware of his criticisms. *Les insolences de Frère Untel* (The Impertinences of Brother Anonymous) might be considered the first important publication in French Canada's quiet literary revolution.

Today, French-Canadian writers talk about all the variety of subjects that concern writers everywhere, but many are also preoccupied with the kind of language that they speak and hear. This and their explicit concern with politics set them apart from their English-Canadian counterparts.

parti pris was the name of a very influential literary and political "little magazine" that existed in Montréal from 1963 to 1968. The declared aims of the group of young intellectuals and writers who founded it were anti-clerical (at a time when the Roman Catholic clergy still had a very strong influence in all the affairs of French Canadians), Marxist and separatist, advocating the separation of Québec from the Canadian confed-

eration and the formation of an independent, French-language country. Many of the most popular Québec writers first published their work in *parti pris* and continue to publish actively although the magazine has long since ceased to exist.

Paul Chamberland is one of these writers, a poet, whose book *Terre Québec* was a kind of long love poem to his country. Chamberland has gone through a number of literary and political transformations. In *L'afficheur hurle* (The Shouting Signpainter) he writes dramatically, often violently, of what he considers to be the outstanding social and political and ideological problems in the Québec of the mid-1960s.

> **I live I exist within a daily death**
> **I live my death until I gasp**
> **for breath day after day**
> **I live an incurable wound**
> **a torn tenderness**
> **a love turned into hate**
> **I live I die with a land**
> **stabbed in the heart of its harvests**
> **and its passions**
> **and my misery is ugly**
> **I cannot name it**

An English translation can be found in Malcolm Reid's book *The Shouting Signpainters*, which discusses the literature and politics of the *parti pris* generation. Today Chamberland, like many young writers, lives in the country and his poetry has moved from the violent, politically engaged earlier writing to the sensual, mystical and mysterious.

Chamberland is a gentle-looking man;

when he reads his poems in public, at universities or colleges or large gatherings of poets, he often wears medieval-looking clothes, bright-coloured velvet trimmed with lace. He is a modern incarnation, in appearance at any rate, of the idea of the romantic poet.

Poets in Québec don't read in public as much as English-Canadian poets do. One who does, and who is a public figure as well known and readily recognized as any movie star or politician, is Gaston Miron. In his forties, Miron is about ten years older than Chamberland; but even at this relatively young age he is considered to be a kind of spiritual father to a whole generation of Québec poets. For years now Miron has been counselling and advising, reading, listening, publishing. He spends so much time promoting and encouraging others that his own work is available only here and there, in scattered magazines and other publications. Luckily for readers, though, when he won the prestigious

Etudes françaises literary prize in 1970, a collection of his poems and some prose pieces were published under the title *L'homme rapaillé.* For English-speaking readers, translations may be found in *Ellipse 5* and in the anthology *The Poetry of French Canada in Translation.* Miron writes of sadness in love, of sensual love, of nature and love. In "La marche à l'amour", one of his most celebrated poems, Miron writes with passion about a woman and some of the physical aspects of his beloved country.

> my ecstasy
> shivering barefoot
> in the glittering frosts
> in this season sweetly studded
> with snowdrops
> on these shores where summer
> rains down
> in long flakes the fiery cries
> of the plover
> harmonica of the world as you pass
> and yield
> your body warm as the birch bark
> in my paddler's arms

Some of his poems are specifically political and he, too, writes from a separatist point of view, with the same kind of passion. When Miron reads he gestures broadly with his arms, his whole body, reading in a booming voice that has the accent of his early years in the Laurentians north of Montréal. Sometimes he sings too, nostalgic old songs about boatmen or "un canadien errant".

As important as Miron the performer is Miron the publisher. His house, les Editions de l'Hexagone, has for some twenty years published the best of the new and established poets in Québec, in handsomely designed, well-printed books, many of which become best-sellers or textbooks or both.

On two recent occasions French-Canadian poets came together to present spectacles that are destined to become legendary in the literary and cultural history of the province. The first was in 1968, when a touring group of writers and musicians presented "Poèmes et chants de la résistance": they toured university and college campuses to show solidarity and raise money for the legal fees of two jailed revolutionaries, Pierre Vallières and Charles Gagnon. The second time was Good Friday, 1970, when a much larger group of poets "performed" at an all-night reading in a Montréal theatre. This extraordinary session was filmed by the National Film Board and released as *La nuit de la poésie.*

In French Canada fewer poets teach in the universities than is the case for the rest of the country. Those who might be considered to form part of the establishment often work at the CBC or the National Film Board or other such cultural bodies. There are schools of poetry – Montréal, Trois-Rivières, Sherbrooke, Québec City – all published by local houses, all with devoted local followings. Many small houses are devoted exclusively to the publication of poetry, often in handsome formats; many small magazines concentrate on poetry.

Québec's *chansonniers* might be considered performing poets, descendants of the French troubadours or relatives of the young American folk-singers. They are poets who set their words to music and then sing them. Georges

Dor, Gilles Vigneault, Félix Leclerc —these are only three of the dozen or more very popular *chansonniers* who attract large crowds when they perform in coffee houses or *boîtes à chansons*; their records are equally popular.

French-Canadian novelists are perhaps less well known by the general public than the poets; their public appearances are even rarer. One exception is Jacques Ferron, who manages to combine a very busy medical practice in a Montréal working-class suburb with a tremendous literary output and even a certain amount of political activity. Ferron was one of the founders of the Rhinoceros Party, a satirical organization that contests a few seats at every election, poking fun at traditional politicians by promising to do outrageous things —or nothing at all —if elected. Jacques Ferron used to publish short stories in *parti pris*; he has written plays, essays, countless letters to newspapers on a vast number of subjects, and a dazzling number of novels. English translations of the novels and short stories are beginning to appear.

His central character is often a country doctor and he writes about the complexity of human relationships from a socially and politically engaged viewpoint. Rich and poor, English and French, the healthy and the sick —all are dealt with in a kindly or ironic way, according to Ferron's sympathies. His huge novel *Le ciel du Québec* borrows contemporary and historical figures from French and English Canada to play unexpected roles or personify certain types.

Ferron is well known as a social critic and it was in this capacity that he helped to radicalize the young Pierre Vallières. Vallières writes about his early friendship with Ferron in the autobio-graphical book *Nègres blancs d'Amérique (White Niggers of America)*. Although the book specifically advocates the use of violence to achieve social and political change (in fact it was for some time banned from Québec bookstores), the autobiographical sections describe, simply and movingly, growing up poor in working-class Montréal. Vallières has long since abandoned his radical politics —he is now an art critic and owner of an art gallery —but *Nègres blancs* is an important, fundamental book that helps explain the sometimes desperate behaviour of certain Québécois.

A classic novel about the same kind of poor working-class life that Vallières lived and wrote about is *Bonheur d'occasion (The Tin Flute)* by Gabrielle Roy. It was written in 1947 and the effects of the Second World War on her characters dominate the book. They live in a run-down part of Montréal, where they have come from the country, and they are nostalgic for the better, simpler life they knew before technology, the war and crushing poverty became their daily fare. Gabrielle Roy comes from Manitoba and she wrote *Bonheur d'occasion* when she first came to Montréal, where she lived in the same part of the city that she describes so accurately. She has also written about her native province, and even about the Canadian far north, but she is probably best known for her account of the misery of Rose-Anna Lacasse and her constantly growing family as they deal with crushing poverty and the unfriendly city where they try to live.

The Second World War and the relations between English and French Canadians are popular subjects for French-Canadian novelists. Roch Carrier's short novel *La Guerre, Yes Sir!* contains what may be the final word on the sub-

ject. It is set in rural Québec and most of the action takes place during the wake for a local boy who has been killed while serving as a soldier somewhere in Europe. There was a great deal of resistance among French Canadians to what was sometimes called "the English war"; some men hid for years in the woods or in their houses, or deliberately maimed themselves to avoid going to war. All these things happen in *La Guerre, Yes Sir!*—rather grotesque behaviour by ordinary people intent on asserting what they consider to be a unique identity. In the end, the English soldiers who bring young Corriveau's body back to his parents, and the inhabitants of the little village, discover that they have a lot in common.

The language of Carrier's characters is distinctive; they don't use *joual*, not on the printed page at any rate, but they swear in a way that is astonishing for English-speaking readers. Rather than calling on bodily functions to express strong emotions, they refer to various articles and aspects of the Roman Catholic Church. Roch Carrier has said that the French Canadians who first used "chalice" and "tabernacle" as swear-words may be considered the first Québec revolutionaries: their target was the dominant Church, and their irreverent use of its appurtenances was an act of defiance. Very satisfying emotionally, and less dangerous than bombs.

La Guerre, Yes Sir! is the first volume of a trilogy (the other books are *Floralie, où es-tu?* and *Il est par là, le soleil*—*Floralie, Where are You?* and *Is it the Sun, Philibert?*) Moving from country to city in the last novel, the young hero Philibert encounters urban woes as he shovels the snow in front of rich people's houses and works in a factory and digs ditches. Life is not particularly happy, but there is a basic *joie de vivre* that endures in spite of everything, suggesting hope for the future, if not for tomorrow.

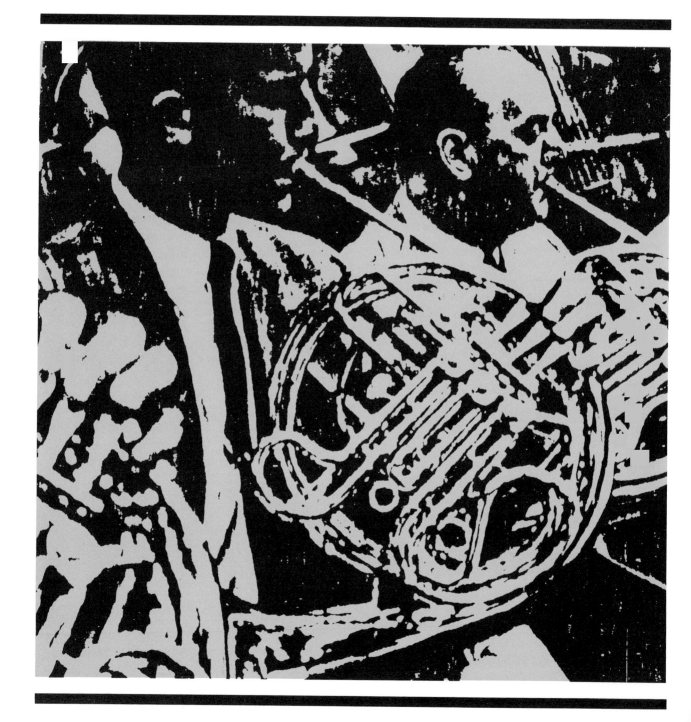

4 New Sound in the Land

> **I'm going to sing the praises of Canada, far and wide, for as long as I can.**
> *— Gordon Lightfoot, 1973*

Canada is a musical country, in the sense that a great many of its citizens have acquired musical skills. Canada has a dozen or so excellent orchestras, hundreds of choirs, many expert rock bands, chamber music groups, concert societies and conservatories of music. It even has half a dozen opera companies (though none yet presents an extensive season of opera).

In two fields, folk music and popular music, Canadians also create widely accepted original music. There are folk music traditions in Canada that stretch back as far as the seventeenth and eighteenth centuries, and in some parts of Canada—Newfoundland is perhaps the best example—these traditions are kept alive by old and young singers today. In modern popular music there are Canadian singer-composers of

distinction. In Québec, for instance, the 1960s produced a whole generation of *chansonniers*, singers who wrote their own songs and reflected their own society; of these by far the most famous, outside and inside Québec, was Gilles Vigneault, whose song *Mon pays* became something like a national anthem of Québec popular culture.

English Canada, too, produced singer-composers, among them Paul Anka, Joni Mitchell, Neil Young, Ian Tyson and Sylvia Fricker: most of these earned enormous fame outside Canada and sometimes were better known elsewhere than they were at home. (Once the Canadian Minister of Finance, when visiting Japan, was told that Japan's favorite Canadian was Paul Anka; the Canadian Minister of Finance had till then never heard of him.) These performers, in many cases, left Canada as soon as they were established or even earlier and settled elsewhere, often in California. They became part of the international world of entertainment, and after a time many of their followers assumed they were Americans.

No one could make that mistake about Gordon Lightfoot. He may have looked, at times in his career, like an American cowboy singer and his accent when he sings may be slightly southern. But his roots have remained deep in Canada. And he made his first great success as a Canadian, in Canada, without approval from outside the country. In 1968, when Lightfoot was already the most commanding presence in English-Canadian folk singing, a Toronto journalist wrote: "It is a matter of some astonishment to Canadians that Lightfoot can pack 'em in anywhere in Canada without having first made it in the States. It is this that makes him a phenomenon."

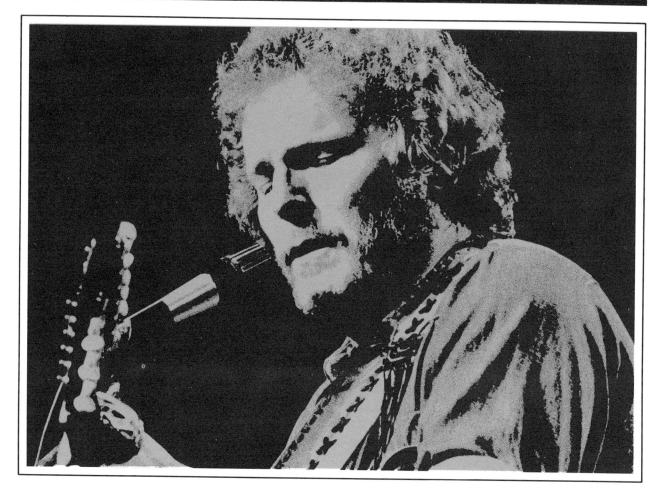

At that time Lightfoot was known only slightly in the United States, but a year before that, in the centennial summer of 1967, the mayor of Gordon Lightfoot's home town had proclaimed a Gordon Lightfoot Day and announced that his name would go up in the town's Hall of Fame.

The town was Orillia—the same town that three-quarters of a century before had produced another notable artist, the humorist Stephen Leacock. Lightfoot studied music there and in Los Angeles and then embarked, in his early twenties, on a career of preparation: he sang with the Gino Silvi Singers, a popular group, on the CBC; he appeared often on the TV program *Country Hoedown*, in a minor role; he had a brief period working for the British Broadcasting Corporation in England. By the mid-1960s he had

taught himself to write songs and was learning how to perform them before audiences. In 1964 the most distinguished of his contemporaries, Ian Tyson (of Ian and Sylvia), introduced him to a New York manager, John Cort. Lightfoot then began to appear in the United States as well as Canada.

Critics following the Canadian folk music scene in those years noticed that Lightfoot was developing an original style. His ballads were about lonely and disenchanted people, much like the people in other folk songs, but he had an especially warm and touching way of describing them. In 1964 Sid Adilman wrote in the *Toronto Telegram* of the characters in Lightfoot's songs as

all migrants scorched by unrequited love, drowning their hurts in liquor and almost frantically searching for a quiet emotional home in some corner of their travels.

Lightfoot the songwriter became internationally known before Lightfoot the singer. By 1966 some of his songs—most notably the hit *Early Morning Rain*—had been recorded by Judy Collins, Harry Belafonte, the Kingston Trio, Peter, Paul and Mary, and Johnny Cash. In 1965 it was on three of the best-selling albums in the United States.

As Lightfoot's success widened, his talent deepened. His lyrics became more intense and personal, often reflecting the difficulties of his own personal life. His love songs became confessional, like modern poetry, stating his own reservations about love. In this his work bore some resemblances to Leonard Cohen's. Songs like *Loving Me* expressed an uncommitted and

defiant attitude toward women: "I've had a hundred more like you. So don't be blue. I'll have a thousand 'fore I'm through." Listeners, whether they liked them or not, couldn't resist hearing their message and talking about it. Lightfoot became a unique personality on the Canadian scene. In Toronto his appearances at Massey Hall, sometimes for five nights running, became an annual institution.

In the 1970s, through recordings and concerts, he became widely known in the United States, and some of his songs in translation became hits in Sweden, Germany, France and Brazil. Among popular singers he remained a unique figure in one way: he seldom appeared on television, despite numerous offers. He wanted to be a private man, to be able to walk the streets alone and unhampered, even in Toronto.

At a record industry dinner one night in 1973, Lightfoot grew emotional about the response of Canadians to his work. "I've been accepted in my native country on a scale I never dreamed possible," he said. He has a close relationship with the Canadian landscape: one of his favourite pastimes is taking long canoe trips on remote lakes and rivers. He also gave Canadians a present: a song about their history called *The Canadian Railroad Trilogy*. It was a kind of folk-song equivalent to Pierre Berton's book on the making of the CPR. It began

There was a time in this fair land,
When the railroad did not run,
When the wild majestic mountains
Stood alone against the sun . . .

The critic Jack Batten described it as "a faithful and moving retelling of a great event in

our history," and thousands of Canadians agreed. Lightfoot, with that song and dozens of others, made a special place for himself within Canadian music.

Lightfoot's generation of folk singers brought their work out of smoky bars and coffee houses and into the concert halls of the country —and so did rock groups like The Guess Who and Bachman-Turner Overdrive, groups that began in Canada and then moved on to international status. Popular musicians like these, who write their own music and then perform it to vast acclaim, have no counterparts in the "serious" music world of Canada—the world of traditional concert music. In this world music usually means performance—and it means performance of work that is mainly written in other countries, in other centuries. Often, however, performance reaches extremely high international levels.

In 1971 a Toronto music critic, Ken Winters, was trying to come up with a definition that would fit Mario Bernardi, the musical director and conductor who had founded the National Arts Centre Orchestra in Ottawa. He settled finally on a description of Bernardi's "classic sense of proportion, his instinct for a silken rhythmic continuity, his inherited Italianate lyricism flowing under his native Canadian practicality." That just about caught Bernardi's special collection of talents, and it hinted also at the background that makes him one of the unique cultural figures in modern Canada.

Bernardi was born in Kirkland Lake, Ontario, the son of an Italian immigrant miner. His father feared that his children would grow up without Italian culture, so he sent Mario at age six

to Italy to live with an uncle. With the uncle he began to study piano. The Second World War kept him in Italy longer than his father had intended; he stayed long enough, in fact, to earn his diploma in piano, organ and composition from the Venice Conservatory at the age of seventeen. In 1948 he was back in Canada to study at the Royal Conservatory of Music in Toronto.

In the 1950s he appeared as a solo pianist and accompanist, and worked as an opera coach. By 1961 he was ready to make his debut as an opera conductor and when he did so, conducting *I Pagliacci* with the Canadian Opera Company in Toronto, he became the first opera conductor to graduate from the Royal Conservatory's ranks. In the next few years he appeared often in Toronto, both as an operatic and symphonic conductor. By 1964 he had made a significant move: to England with the Sadler's Wells Opera Company in London, first as a vocal coach, then as a conductor, and finally as musical co-director of the company. At that point he was still only thirty-five years old and clearly the most promising conductor of his generation that Canada has produced.

In England his talents were generously recognized. A critic for the London *Observer* wrote that he was "a Verdi conductor in a thousand. I have rarely heard Verdi better conducted—anywhere." Bernardi kept in touch with Canada, returning several times to conduct here.

In 1968 a new orchestra was being created in Canada. Officials at the National Arts Centre, the federal government's Centennial gift to the city of Ottawa, had decided to develop a resident orchestra. The decision was made to create not a huge orchestra (like Toronto or Montréal) but a

more modest-scale chamber orchestra of forty-four or forty-six players—the sort of orchestra that Haydn and Mozart wrote for. A chamber symphony could perform much of the classical repertoire and a great deal of the work of modern composers. Perhaps more important, it could tour Canada (and other countries) without enormous costs. Bernardi was asked to return to Canada to create it, and he agreed. As he said, "How could I possibly resist the opportunity not just to take on an orchestra but to make one?"

In the summer of 1968 he arrived in Ottawa and began a full year of preparation. He auditioned some two hundred players before he chose the forty-four who would be members. He also found himself in a delicate political situation; some idea of the problems inherent in the small world of Canadian music can be drawn from a few remarks he made years later:

There were so many difficulties it was something of a miracle that the orchestra came into existence. We had a lot of ill-will, happily now forgotten, from the other musical organizations in Canada who thought their status was being threatened. They were quite reasonably afraid that we might steal their best players. In fact, we had to make a solemn promise not to 'cannibalize' the other orchestras . . .

Eventually the orchestra came together and in October, 1969, made its debut. The critics were delighted; more important, the Ottawa au-

dience was enthusiastic. Soon Bernardi and his orchestra were out touring Canada; in the next few years they visited fifty-five different cities and towns. In 1973 they toured Europe, from Rome to Moscow, and received excellent reviews. That year William Littler, the Toronto *Star* music critic, described the NAC Orchestra as "Canada's Cinderella Band" and the *Times* of London said it was becoming "one of the leading larger chamber groups in the world." In a very brief span of time, the NAC Orchestra and Mario Bernardi had arrived. They had become an important part of the texture of music in Canada, and they had established their credentials on the international scene as well.

The composers whose work is performed by Bernardi's NAC Orchestra and the other orchestras across Canada are only occasionally Canadian. Serious music in Canada remains ninety-nine per cent imported. To understand this we have to look back at the development of music in Canada. Helmut Kallmann's book, *A History of Music in Canada, 1534-1914*, makes it clear that even by 1914 the profession of music had scarcely been established in Canada—except for church organists and choirmasters, some teachers and a few instrumentalists of quality. Permanent orchestras had only just begun to appear—the Québec Symphony Orchestra was established in 1903 and the first Toronto Symphony Orchestra four years later. Various philharmonic societies gave concerts and the large amateur choirs reigned supreme; but when a group like the famous Toronto Mendelssohn Choir (founded in 1894) wanted to perform Beethoven's Ninth Symphony it hired the Philadelphia Orchestra.

Curiously, the movies helped Canada's musical situation. In the 1920s the silent-movie theatres needed not only pianists but sometimes full orchestras to accompany the films, so jobs in movie theatres helped to make music a paying profession. This attracted many musicians from Europe, and by 1923 a group of these had revived once again the Toronto orchestra (it had been suspended during the First World War) and orchestral music settled into that city for good. Toronto at that time, and indeed until the 1950s, was the only city in Canada with a good concert hall for orchestral music—Massey Hall, given to the city by the Massey family in 1894. Toronto also had the Toronto (now the Royal) Conservatory of Music, the country's leading music academy until well into the 1950s.

Taking the presence of a good symphony orchestra as a guide, Toronto is musically speaking only two generations old—and the rest of the country is even younger. The present Montréal Symphony orchestra was not established until 1935 and had no good concert hall to play in until 1963. In 1955 there existed in Canada only three good concert halls, only one of them having been specifically designed for orchestral music.

But in the 1950s and the 1960s concert halls began to sprout up in almost every important city in the country—in 1957 in Edmonton and Calgary, in 1959 in Vancouver, in 1963 in Montréal, in 1966 in Saskatoon. Major buildings which are respectable settings for music appeared in the 1970s in Regina, Winnipeg, Québec City, Halifax and Hamilton. The possibilities for hearing good music in Canada increased enormously in this period.

The boom in concert hall construction re-

flected a quickening interest in the arts as a whole and a sense that Canadian society, now relatively prosperous, could afford to assist the arts. The establishment of the Canada Council signalled this new mood, and a decade later music was given a prominent place in the celebration of Canada's one-hundredth birthday. That year, 1967, brought a nationwide festival of the arts which was subsidized by the federal government on a scale previously unknown. Expo '67 in Montréal included the World Festival of the performing arts, probably the largest such festival held anywhere in modern times.

The buildings are only the most obvious signs of a transformation that has changed all the possibilities of musical life in Canada. There have always been Canadian musicians of talent, but until recent years they had to leave Canada to achieve full professional status. In the late nineteenth century Emma Albani was one of the great sopranos of the world; she had been born Emma Lajeunesse in Chambly, near Montréal, in 1847. In the early years of this century Kathleen Parlow was a world-famous violinist; she was born in Calgary; Edward Johnson, known on Europe's opera stages as Eduardo di Giovanni, was born in Guelph, Ontario, in 1881. There was no dearth of talent in earlier Canada, but talent needs good instruction and opportunity to develop, and most Canadians of an earlier time needed to go abroad to study and find their way into the musical profession. In recent decades this has not been so. Major figures like Lois Marshall, Louis Quilico, Glenn Gould, Maureen Forrester and Teresa Stratas form the first generation of Canadian musicians to reach fully professional status *within* Canada. Jet travel makes it possible for more and

more of these artists of world stature to continue to live in Canada, thus maintaining closer ties with their own country and making a direct contribution to it—as the opera singers and recitalists of previous generations could not.

These developments have set the stage for the emergence of the Canadian composer. And indeed, in the decade after the Second World War there was an explosion of musical creativity in Canada. In the mid-1930s one could find no more than three or four Canadian musicians who were primarily composers. By the mid-1950s the Canadian League of Composers (formed in 1951) had three dozen members. By the mid-1970s it had nearly twice that number. In the 1970s the Canadian Music Centre was able to list over 100 "associate" composers across the country. And by then about twenty-five universities and other schools in Canada were giving degree courses in composition. Canadian composers, if they had not become popular, had at least become a substantial factor in the country's cultural life.

But the long-ago story of Calixa Lavallée tells a great deal about the history of music in Canada, and even something about the fate of Canadian composers in our own time. Few Canadians even know Lavallée's name, yet he wrote the tune to our national anthem, *O Canada*, and he was our first native composer.

He was born in 1842 in Verchères, Québec, to a family interested in music. Early he showed musical promise but he was impatient with the prospect of local training, and decided to travel in the United States and pick up musical experience wherever he could: he even enrolled in the Union army during the American Civil War

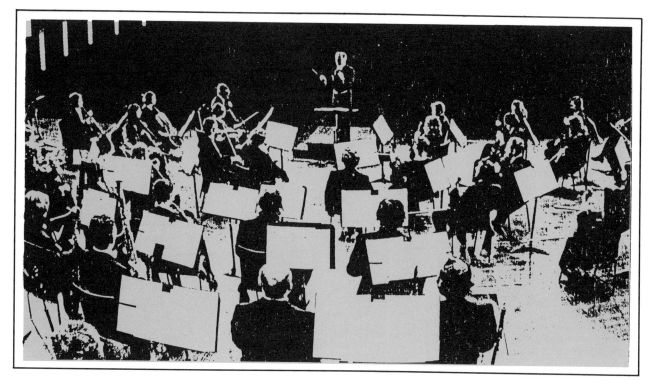

and became a regimental bandmaster. After the Civil War he returned to Montréal but could find no scope for his talents. Again he went to the United States, teaching in New Orleans, travelling as an accompanist on concert tours, and living in New York as a conductor in musical theatre. By now he was composing music, but without great success. Back in Montréal he was well received and money was raised to allow him to study in Paris. There he had a symphony performed.

When he returned to Montréal he tried to found a conservatory and failed (such a venture was not successfully begun until almost a century later), but he gradually became accepted as the first Canadian composer of substance. In 1880 he

was chosen to write Canada's national song, to words by Judge Adolphe Routhier. He was still discouraged by the low estate in which the musician was held in Canada and he moved again to the United States. There his career flourished: he was an organist, a conductor, a composer, and a teacher—indeed, he became president of the national music teachers' association. He died in Boston in January, 1891.

Lavallée's music strikes us now as very much "of the period"—somehow, the sound of the the cornet pervades it all. Yet he should be more widely known to Canadians. He has a natural gift of melody and much of his music would bear revival: the CBC has gone some dis-

tance in this direction by issuing a recording of excerpts from his opera *La Veuve* (The Widow). Lavallée wrote at least four operas, five choral works with orchestra and some three dozen other works ranging from symphonies to solo piano pieces. His piano piece *Papillons* (Butterflies) was played in concerts, examinations and genteel parlours the world over.

As a Canadian Lavallée was much ahead of his time: he needed, for the complete development of his talents, a complex and well organized musical society and a public interested in the music of its own time and place. He did not have those, and a great many other Canadian composers have suffered from the same unfilled needs. Canadian music in his time was in the earliest stages of development; it is still in that process, though the process is now much advanced.

The first important Canadian composers in this century wrote music in the only way that seemed possible to them — in imitation of European styles. Guillaume Couture (1851-1915) and Alexis Contant (1858-1918) were both substantial figures in their time. Almost all of Couture's music is religious and his oratorio *Jean le Précurseur* (1914) has rightly been called a monument in Canadian music. Contant, who was a church organist for most of his professional life, composed more sacred music than secular. His oratorio *Cain* (1905) was the first Canadian oratorio to be given a performance in Canada, and Contant is probably also the first Canadian composer to whose music an entire concert was dedicated (in 1903).

Today folk music is respected *everywhere* for its authenticity and originality, but this was not so in Canada until recent decades. In 1865 Ernest Gagnon's book, *Chansons populaires du Canada*, a collection of folk songs, was received with some enthusiasm by the urban middle classes of Québec. But the *musiciens savants* ignored it. As late as 1914, one could hear the learned opinion that "from the academic musical standpoint the melodies have little interest. They are unconventional to excess. Many of them are not to be classified either in the major or the minor mode." Elsewhere in the world composers like Cecil Sharp and Vaughan Williams in England, and Kodaly and Bartok in Hungary, were finding in *their* national folk cultures a freshness and direct power of expression on which they were later to build their own distinctive national styles.

But perhaps that could happen only in a more mature musical environment, secure in its own self-knowledge. Perhaps in Canada (as in the United States) the colonial inferiority complex could not yet permit a return to the relatively unsophisticated. Canadian composers did not take this route until a generation later, in the late 1920s, when the folklorist Marius Barbeau collaborated with musicians like the Englishman Healey Willan and the British-trained Canadian Ernest MacMillan.

Charles Marius Barbeau, a man of native artistic sensitivity, wide-ranging tastes and great energy, had been moved to listen more closely to the songs of his own French Canadian people and to the songs of the Indian people near Québec City. He set as his life's work the discovery of the artistic folklore of French Canada, Nova Scotia and the Indian peoples from one end of the country to the other. By the mid-1920s his researches began to find expression in books,

and the books attracted the interest of professional musicians, notably Ernest MacMillan.

In the 1920s and 1930s a brief nationalistic movement produced a number of works still played and enjoyed by audiences in our concert halls, among them MacMillan's *Two Sketches on French Canadian Airs* (1972) and Willan's *24 Chansons canadiennes* (1929).

But by the 1930s new winds were blowing internationally from the music of such composers as Igor Stravinsky, Arnold Schoenberg and their respective disciples. The new music represented a sharp break from the past, particularly from the older melodic ideas on which music (including folk music) had been based for centuries. Most concert audiences still find such music unsettling.

Among composers the wide acceptance of the twelve-tone scale and other new principles largely drew their attention away from the possibility of developing their music out of melody. And so the folk-based nationalist movement in Canadian music was doomed to an early death. The new generation of composers began to develop in the late 1930s and then burst on the scene in the years just before the Second World War. This was the generation of (in Toronto) John Beckwith, Harry Freedman, Barbara Pentland, Godfrey Ridout, Harry Somers and John Weinzweig, and (in Québec, mainly Montréal) Alexander Brott, Gabriel Charpentier, Roger Matton, François Morel, Pierre Mercure, Jean Papineau-Couture, Clermont Pépin and Robert Turner.

These composers, many of whom had studied with the leading European figures of the era, were the first Canadian generation to stand for the new music. They found themselves very much at variance with the musical understanding of the communities in which they lived and worked – even with the musical profession itself. Canadian performing musicians were on the whole still immersed in the great classical and romantic traditions of Europe.

The Toronto composers formed the Canadian League of Composers in 1951 and this almost immediately extended itself to Montréal and Vancouver. The League set about acquainting the public with their music through concerts in both Toronto and Montréal, persuading the CBC to give greater exposure to the substantial body of new Canadian music which was by then accumulating, and generally trying to establish the fact of their presence as a new force in the Canadian arts. In the CBC they found a willing ally: its International Service had begun to record Canadian music for international distribution immediately after the Second World War. From then until the present the CBC has been a staunch supporter of Canadian music.

By the mid-1950s, a second generation of Canadian composers had begun to emerge, most of them students of the post-war Weinzweig-Papineau-Couture generation. These were the first Canadians to be trained mainly in Canada, and they included R. Murray Schafer (who settled in Vancouver), Bruce Mather, Brian Cherney, Srul Irving Glick and Charles Wilson in Toronto, Serge Garant and Jacques Hétu in Québec City, and Gilles Tremblay, André Prévost and John Hawkins in Montréal.

These names at least suggest the dimensions of development in Canadian music in this period. There has been no parallel development in audience enthusiasm for the music these men

and women have produced. Canadian music is thus in the position of Canadian painting about a quarter of a century ago—there are many talents on the scene, they are producing much that is interesting, and they are looking for an audience. Each of the mature composers has his own approach to structure and development, his own "sound".

Murray Schafer was once asked if there is, or ought to be, a distinctive Canadian music. He answered testily, "There isn't and there oughtn't." And this reflected the opinion of almost all of his colleagues. Yet later, in a talk to some students, Schafer said that no artist can ignore his environment and that somehow—often quite unconsciously—this will affect his art, even if that art is music.

Certainly there is a spareness—often a bleakness—that turns up in the works of Canadian composers and this may well be related to the Canadian environment. "The long lean line" has been hailed as an almost "typically Canadian" trait, especially in Harry Somers' work. There are specifically Canadian references, too, such as the cry of the loon in Somers' song cycle, and his work called *Five Songs of the Newfoundland Outports*. And Somers is best known for his opera, *Louis Riel* based on Canada's most famous nineteenth-century rebel leader.

Somers' concerns are more with music than with Canada, of course, but in some ways he stands forth as the typical Canadian composer of his period. He works in Toronto and devotes most of his time to composition. His works are played across the country and sometimes at international festivals, they appear on the CBC and on recordings, he writes on commission (such as

his score for the National Ballet's *The House of Atreus* in 1964). He is known only to a minority of Canadians but among them he is widely esteemed. When he set out to write music in the 1940s there was no such thing as a Canadian composer who earned his living by composition. Now there is, and that suggests considerable hope for the future. As Somers once said, "Since my school days things have improved so remarkably that I'm really optimistic." Canadian composers have reached the point where they can afford a certain optimism.

5 The Problems of Success

In the years following the last war there were so few theatres in this country that the only way a director could get work was to start a theatre of his own. Today, there are several dozen fully professional theatre, dance and opera companies ... which says something, I think, about the deep-rootedness of theatre as an element of human life and culture.

— Jean Gascon, 1974

The theatre of Canada changed forever on the night of July 13, 1953. That was the opening of the Stratford Shakespearean Festival and it was the beginning of theatre as we know it in Canada now. On that hot and humid night, in a big tent set up beside the Avon River, about 1900 people watched Alec Guinness, a leading English star, play in Shakespeare's *Richard III* with a company of Canadian actors.

Most of the people who were there knew something important was happening; many of them suspected that a new day was dawning for theatre in Canada and perhaps even for the other arts as well. Possibly that was why, at the end of the performance, they reacted as they did. The late Nathan Cohen, who was for years the leading drama critic of English Canada, set down his memories of that night:

> **And when it was all over, when the lights came on near midnight, and the actors started to come out to take their bows, we went wild.**
>
> **We began in the conventional way, clapping hands. But that just wouldn't do. So we stood up. I mean we all stood up, as one, and applauded, but that wouldn't do either.**
>
> **So then someone started cheering, yelling 'bravo' and 'hooray,' and the cheers kept getting louder and the actors kept coming back ... and it seemed it would never stop.**
>
> **The people in business suits and the men in evening dress, the women in summer skirts and in gorgeous evening gowns, were screaming from the bottom of their throats, in praise, in gratitude, in a delirium of joy ...**

That was the night it all began: the regional theatres, the festivals, like Shaw and Charlottetown, the little theatres producing Canadian plays, the university drama departments — the

whole vast panoply of professional Canadian theatre in both English and French.

Today theatre across Canada is well-financed and well-attended; it is part of the life of the country. But before that night in 1953 it was a kind of cripple. What we had in those days, as the playwright and novelist Robertson Davies put it, were "under-rehearsed, under-dressed, under-mounted, under-paid, and frequently ill-considered and ill-financed" theatrical projects. There were occasional breaks in this darkness—like little theatre companies in Montréal or Toronto, occasionally even with their own playwright—but these were rare until 1953 and the "miracle" (as so many called it) of Stratford.

Stratford, Ontario, was at best an unlikely place for the birth of such a movement. It was then a sleepy railroad town of 19 500 people. There had been no live theatre there for half a century, and the people showed no special interest in the arts; their main interest was hockey. The town was named after Shakespeare's birthplace in England, Stratford-on-Avon, but that

was only the whim of a land developer in the nineteenth century—it was then common to name Canadian places after English places, like London or Windsor. That same nineteenth-century land developer also called the river beside Stratford the Avon, like the one beside Stratford in England, and the town carried on the tradition in a small way by naming wards of the city or schools after Shakespearean characters. There was also a garden in the park by the Avon which contained all the flowers mentioned in Shakespeare's plays. But the plays themselves were of only marginal interest in Stratford—until Tom Patterson.

Tom Patterson grew up in Stratford. Sometime during his boyhood he decided it would be a fine idea if Stratford became a new home for Shakespeare's plays. He was a journalist in Toronto, thirty-two years old, when he began organizing a Festival in 1952. He got some help from the Stratford city council and spoke to theatre people in New York. But his great breakthrough came when he telephoned Tyrone Guthrie in England.

Guthrie was to become the guiding spirit of the Stratford Festival. He was then a successful director of both Shakespeare and modern plays, with a world-wide reputation. But he saw the chance for a great new adventure in Stratford, Ontario—he could start afresh, could apply his own ideas of Shakespearean production to the theatre as well as the plays themselves.

He came to Stratford in the summer of 1952 and met the city council and other backers. He told them a Shakespearean Festival would not make money (there he was wrong, it greatly enriched the town) but that it would be worth doing. He offered his help. "If you want to try to produce the finest Shakespeare in the world, and give Canada more than wealth and industry to be proud of, then I think you can do it, and I'll be with you all the way."

The Stratford people said yes. Guthrie went back to England and hired Alec Guinness and Irene Worth as the stars of the first summer's plays—*Richard III* and *All's Well That Ends Well*. He interviewed scores of Canadian actors and chose some of them as principal players; he also imported two more actors from Britain. He hired Tanya Moiseiwitsch, a stage designer of great reputation, to prepare costumes and props. Together Guthrie and Moiseiwitsch designed for Stratford an open stage that was unique in the world—a stage that, in the decades to come, would be marvelled over by critics from a dozen countries.

There were serious difficulties that first season. At one point, not long before opening night, money ran out and the whole idea was almost abandoned. (This was four years before the Canada Council was founded.) At the last moment substantial gifts from two private companies saved the situation, and the Festival opened. Once that triumphant opening night had happened, success was assured. A five-week season had been planned, but it was extended to six and the theatre was nearly full most of the time. Box-office receipts, reviews in the Canadian and American newspapers, reactions from visitors: all were better than anyone, even Tom Patterson, had anticipated.

From there, Stratford went from success to success. Soon it began to produce works by other writers, from Sophocles to Chekhov. In 1956 the

tent was replaced by a permanent theatre. A downtown movie theatre was purchased for use as a second theatre, and later a third was added. In 1953, about 68 000 people attended; in the 1970s the total attendance went close to half a million. In the first year the box office gross was $206 000; in the 1970s it climbed to more than $2.3 million.

The Festival also transformed Stratford itself. New hotels opened, as well as restaurants and gift shops. An Ontario government report said that in the 1970s summer visitors spent about $8 million a year at Stratford. The town became a desirable place to locate business and industry: thirty-eight new industries have arrived since 1953. The Festival is itself an industry: it has a year-round staff of seventy and at the height of the season employs 650 persons.

But more than that, the Festival transformed Canadian theatre and its ideas about itself. Within a few weeks after the opening night Robertson Davies wrote, prophetically:

> **It has given . . . a new vision of the theatre, and a new realization of what our Canadian actors can do when they are given a chance. It might also give a new inspiration to our playwrights . . . The Stratford Festival is an artistic bombshell, exploded just at the time when the Canadian theatre is most ready for a break with the dead past and a leap into the future.**

Davies could have gone further: he could have suggested that the Stratford Festival would mean something important for the arts in Canada

as a whole. It gave some of the people involved in the arts in Canada their first sense that they could do something that might be important in the world as well as in Canada. It was one reason why many people worked so hard in the next few years to persuade the federal government to establish the Canada Council, a government agency to provide funds for the arts. Stratford showed what could be done without government help; what further miracles might be accomplished if the government provided help. In 1957 the Canada Council was established, and that in turn made possible the new professional theatre of Canada.

But there were many struggles ahead; in fact, theatre was always to be a struggle in Canada. In French Canada you can see the difficulties of the theatre's existence through recent decades in the remarkable life story of a single theatre company—Le Théâtre du Nouveau Monde (New World Theatre).

The TNM began officially in 1951 but its roots stretch back at least to 1940. In that year two extremely talented young men, Jean Gascon and Jean-Louis Roux, performed with a semi-professional company in Montréal, the Compagnons de Saint-Laurent. That group was directed by Father Emile Legault, who saw theatrical activities as an extension of his youth work in the church. Both Gascon and Roux were medical students, but under Father Legault they also became fervent students of the theatre. In 1946 both of them accepted French government grants and went off to study theatre and to work in Paris.

It was in Paris that the TNM was first talked about: Gascon and Roux imagined a company that would be professional, would be devoted to the classics, but would be open to the new impulses in the theatre. At that time there was already a lively theatrical scene in Montréal, both in French and English. Gratien Gélinas, who has been a major figure in the dramatic arts in Canada for more than three decades, was then the director of the Comédie Canadienne and was famous as playwright, director and performer: his play *Ti-Coq* was an enormous hit in Montréal and was performed in Toronto and New York as well. But Gascon and Roux saw a need for their kind of company, and in 1951 they organized it. Gascon was made artistic director, a position he held until 1966. That year he resigned and later moved to the Stratford Festival, where he served as artistic director from 1968 to 1974. He remains a unique figure in Canadian culture, the only man or woman who has functioned on the highest artistic levels in both English and French theatres. At the TNM, when he left in 1966, he was replaced by his old colleague Roux.

While Stratford was founded on the work of the greatest playwright in English, the TNM was founded on the work of the greatest playwright in French—Molière (1622-1673), the creator of French classical comedy. When the TNM opened, on October 9, 1951, at the Théâtre du Gésu in Montréal, its first play was *L'Avare* (the Miser), by Molière. "I think," Gascon said in later years, "the production of *L'Avare* met all our expectations. Definitely, Molière was a symbol for us . . . we believed in French classical theatre . . . we were young, it was a fresh start and we had a good response from the public. We took it for granted the entire public was interested in theatre." On opening night the program

proudly announced: "We plan to win public support by the quality of our performances and to become established as a permanent professional company." Permanence was to be a long time coming, but there was never any question of the quality. As the Montréal *Star* critic put it, this was "a company which may some day be compared with famous Paris companies."

Since that night in 1951 the TNM has done many kinds of plays, from Chekhov to Bertolt Brecht, from Paul Claudel to Tennessee Williams. It has often produced Canadian plays, by writers such as Marcel Dubé, Claude Gauvreau and Roch Carrier. It has performed some remarkable experiments, like translating George Bernard Shaw's *Pygmalion* into Montréal French so that its message of class distinctions based on language was set forth in a way Montréalers would appreciate. But through all this it has come back again and again to Molière. In an interview in 1962 Jean Gascon explained why:

> **I think Molière is a fantastic author. Even when you say "I've seen enough Molière," the first second the curtain opens, the fantastic step, the stride of the old man catches you, with his language, his vigor, his genius . . . you can't resist that.**

But just as Stratford attempted a new kind of Shakespeare, so the young men and women of the TNM earlier tried to find a new way of doing Molière. As Gascon has rightly said, they made the Molière plays "very vigorous, very alive, Rabelaisian . . . people suddenly realised the incredible flesh and bones and blood of the old man." In France and in Québec, Molière had

been done with too much politeness; the new company would sweep away all that.

The TNM made its first trip outside Canada in 1955: it represented Canada at an international theatre festival in Paris, performing—on Molière's home ground—three of his short plays. The critic of *Le Monde* saw what Gascon and the rest were doing, and appreciated it: "Verve and naturalness permeated all . . . They are full of audacity and they have spirit . . . They have youth, are not stilted or artificial . . . We applaud it with joy. We are happy that there is in Canada a young troupe so ardent and so capable of presenting Molière."

Over the years, TNM's reputation grew, at home and abroad. In 1958 it played (Molière again, but this time also a Canadian play, by Marcel Dubé) at the Théâtre de Nations in Paris and at the World's Fair in Brussels. In 1965 it appeared at the Commonwealth Arts Festival in London. Several times it played at Stratford, Ontario, in Toronto and in New York. In 1961 Nathan Cohen wrote in the Toronto Star:

> **It is an outstanding theatre organization by the highest standards, at the very least the best in North America, deserving of our awe and profound affection.**

But while Stratford was flourishing financially, the TNM—despite great artistic success—was in constant difficulty. That trip to Paris in 1955, for instance, almost didn't happen; the company was denied government funds to represent Canada and had to scrape up money on its own. In 1962 the Montréal critic Robert Russel noted that the company had to fight to stay alive.

"Each season became a battle, a lottery, an all-out try for the smash success needed to save the company for another year." Moreover, the TNM—again, unlike Stratford—was never sure, from year to year, where it would be putting on its performances. It had no permanent home and it moved restlessly from theatre to theatre.

By 1966 there was even talk of letting the company die. Late that year Jean-Louis Roux was asked whether the company could survive. "I don't think we can," he said. "We can last for a while only but even if we do survive as we are now, we won't be making any progress and in that case I don't want to be merely a rescuer." But the TNM did survive, and eventually it found permanent quarters. In 1968 it moved into the Theatre Port Royal at the Place des Arts, a handsome structure which had been built in centennial year. There the TNM was still a tenant, but in April, 1972, it finally moved into a building of its own. The theatre at the corner of St. Urbain and St. Catherine had been built in 1911 as the Gayety, and had housed burlesque, later movies, and still later the Comédie Canadienne of Gélinas. It was purchased for the TNM by a special grant from the Secretary of State's department. Finally the TNM ended its long era of crisis. It was twenty-one years old and finally had a home.

The TNM was always professional in quality, but at the start it operated on an amateur scale. Most of the actors earned their living by performing on Radio-Canada, and the entire budget for the first season of four plays came to only $45 000. In recent years, with large government grants, the TNM has become much more affluent—sometimes now a budget for the

season will go close to the $1-million mark. Naturally, like Stratford, it has come to be seen by a new generation as "establishment." Jean-Louis Roux pointed out in 1971:

> **Our company more and more is coming under fire, attacked by this group, spat upon by that, accused, in turn, of flirting with terrorism or being the hirelings of the power élite; we're a hideous establishment, as far as the radicals are concerned, yet scandalize *the* Establishment. We're caught in the middle.**

The TNM had thus acquired all the problems of success.

There were other kinds of success in Québec theatre, however. One of the most notable was the success of Le Théâtre du Rideau Vert, an institution which by the 1970s had become the oldest professional theatre in Canada. Le Théâtre du Rideau Vert has been, in its time, all things to all theatregoers—it has done French farces and Broadway comedies, original Canadian plays and Chekhov, Shakespeare and Harold Pinter.

It began in 1948, under the guidance of Yvette Brind'Amour, a remarkable Montréaler who has ever since been its director and one of its major performers. "When we began," she has said, "there was not one professional company operating, just amateurs and visiting troupes. We created a public that got into the habit of going regularly to see plays."

When Yvette Brind'Amour was seventeen years old, and not particularly attached to any way of life, she answered, on a whim, a news-

paper advertisement asking for young people to take part in amateur productions. That same year she played her first part, in a Mauriac play with the Montréal Repertory Theatre. She remained there for four years. For another five years she performed in radio plays and with other theatre companies. Then in 1948, with her collaborator Merecédès Palomino, she began putting together Rideau Vert.

They put on their first production, a translation of a Lillian Hellman Broadway play. It succeeded and they tried another. Soon they were into a regular schedule. The productions were not lavish: actors played for nothing or for three or four dollars a night. The first time they made money was with a Canadian play, Félix Leclerc's *Sonnez les matines.* Year after year they built audiences with boulevard comedies from France.

By 1959 they were ready to announce an entire season of plays by French-Canadian writers; in the 1960s they discovered a good many writers—among them Michel Tremblay, whose *Les Belles-Soeurs* opened at Rideau Vert in 1968, launching a career that was eventually to take his plays across English Canada, to Paris, and to New York. In 1965 the Rideau Vert played in France and Russia, and in 1966 the Russians returned the compliment by sending one of their Moscow Arts Theatre directors, Joseph M. Raevsky, to direct a Rideau Vert production of Chekhov's *The Three Sisters* in Montréal.

Working at its own Stella Theatre in Montréal, the Rideau Vert became an institution. Long after it had become well established, Yvette Brind'Amour was asked to look back on her early days and compare them with the present. "We have had quite a hard time," she said—and in this she might well have been echoing a thousand other dedicated Canadian artists. "But now it is getting better. Now we get grants from Montréal and from Québec Province. But before that we had to live on our own. At that time I did a lot of radio work, and I put the money into the theatre." In 1973 Yvette Brind'Amour and the Rideau Vert celebrated their twenty-fifth anniversary and the reporters came around to offer their congratulations and seek interviews. But Yvette Brind'Amour had the last word: "I am not an institution yet!" she said.

Michel Tremblay, a member of another generation and a man with a totally different outlook on theatre and art in general, yet a man closely linked in the beginning with Brind'Amour, was also in danger of becoming an institution. In 1972, only four years after his career was launched at the Rideau Vert, Tremblay had been performed on television, had seen his French-Canadian version of Sophocles' *Lysistrata* put on at the National Arts Centre in Ottawa, and had even seen *Les Belles-Soeurs* become a part of the curriculum of certain Québec high schools. "That's really too much for me," he said at that time. "I don't want to become an idol."

And yet, for certain people absorbed in the theatre and certain issues of modern Québec, Tremblay was in fact becoming something of an idol.

The remarkable thing about this is that the way he writes is not—according to tradition—the basis for becoming an idol, or even a success. Tremblay writes in *joual*, which is Québec slang. His language is the language of the streets and the back alleys: it is French without cultivation, without formal education. It is French mixed with

English and anything else that comes along. As an example, Tremblay may have a character make an order in a restaurant:

> **Deux Cokes! Un smoked meat fat avec des pickles, un sandwich au jambon salade mayonnaise, un ordre de toasts, un milk-shake au chocolate. Deux hamburgers platters pis pas de cole-slaw . . .**

Just a decade ago almost all French Canadians who expressed themselves in public believed that this sort of French was improper, perhaps even shameful. But Tremblay, and a few other playwrights and novelists, have made it a part of literature.

The process was fast but not easy. When Tremblay wrote *Les Belles-Soeurs* in 1965 when he was a twenty-three-year-old printer, he had only vague hopes of seeing it produced. And in fact several theatre companies turned it down. Even when Rideau Vert accepted it, the play posed problems. Québec actresses had been taught to speak properly (as much like Paris French as possible) and they found it hard to speak Tremblay's version of French on the stage. "We had some trouble," he acknowledged at the time. "You could say that it is the language of alleys and back streets. These women have to speak in the loud, coarse manner of women who converse while hanging out the wash in the backyard." Tremblay's writing often deals with the slums of Montréal. His characters are victims of deprived and repressed lives.

He has since had several plays produced to enormous acclaim in Toronto and then produced again in regional theatres across Canada.

Hosanna, his play about two homosexuals playing different sexual roles, had less of a success in New York than in Toronto but nevertheless attracted international attention.

Tremblay is a Québec separatist and he believes that in a way his plays support the separatist point of view. But they do not contain obvious political views. As he says: "I hate political theatre. I think it's boring. We don't have to say political things onstage, we just have to be what we are. When people come to see my plays and say, 'My God, are we really like that?' it's much more political than having one of my characters say, 'Vive Québec libre!' " He thinks the most separatist act a Québec playwright can make is to show how different the Québec people are – "it will be clear that we have to be independent."

The theatre of English Canada in recent years has – like Le Théâtre du Nouveau Monde – enjoyed the problems of success. First there was the problem of money. Then there was the problem (and also the opportunity) of playwrights. Neither was easy to solve.

The founding of the Canada Council in 1957 provided enormous impetus. In the 1960s professional theatre began to spread across Canada: Winnipeg, Edmonton, Calgary, Vancouver, Halifax. Two key figures in the development were Leon Major and John Hirsch. Major, originally from Toronto, founded the Neptune Theatre in Halifax and later moved back to Toronto to direct the St. Lawrence Centre. Hirsch founded the pioneering Manitoba Theatre Centre in Winnipeg, later went on to international success in the United States and Israel, and in 1974

became chief of drama for the Canadian Broadcasting Corporation's English television service.

The founding of the Manitoba Theatre Centre illustrates some of the problems and some of the opportunities that Canadian theatre faced a generation ago. In the late 1950s Winnipeg – and in fact the whole province of Manitoba – had been without professional theatre for about three decades. There was the Winnipeg Little Theatre, an amateur group, and there was Theatre 77, a group formed by John Hirsch. They were the

best theatre Manitoba had to offer and in the 1950s they were mounting their productions in the Dominion, a converted old movie theatre. The journalist Christopher Dafoe, who worked there as a stage manager, has recalled the atmosphere:

> **Pigeons used to flutter down through holes in the roof and roost on the set during performances . . . bits of plaster occasionally fell like snow. On one occasion a large section of the back wall caved in during a performance . . .**

In 1958, under Hirsch, the Winnipeg Little Theatre and Theatre 77 came together to found not a theatre only, but a *Centre*, as the name said. A Centre that would have a children's theatre as well as an adult theatre, that would encourage playwrights as well as actors, that would have a school attached to it and would tour the province.

Tom Hendry was a founder, with Hirsch, of the MTC. In 1974, reminiscing about that period, he wrote: "From the outset we were aware that we were founding what would become the cornerstone of a decentralized National Theatre network for Canada." Incredibly, that's just how it turned out. The MTC provided the model that others could follow as regional theatres spread across the country.

Considering that it was operating in a city without a substantial theatrical tradition, the MTC was audacious. It produced Brecht, Albee, Strindberg, Shaw. It gave a hearing to Canadian writers like James Reaney, Len Peterson, Bernard Slade, and Betty Jan Wylie. It brought in the

best actors and actresses from across the country: Kate Reid, Douglas Rain, Martha Henry, Pat Galloway, Leo Ciceri. It produced, in its first few years, a degree of excellence that made it the envy of theatre people across Canada.

There were grants to help the theatre along, and a great many local people who gave time and energy, but the most important part of the impulse behind the MTC (and this is true of many other artistic activities across the country) was an almost moral sense that this thing *should*

be done. John Hirsch, long after he left Winnipeg, tried to recall how he felt in those early years:

> I was aware of the European pattern in which every small provincial town had its own theatre. I saw no reason why Canada couldn't have the same . . . I found it outrageous that there was not a children's theatre. I found it incomprehensible that there was not a major public theatre. I found it scandalous that students who were studying Shakespeare and Shaw in school had never had the opportunity to see those plays in the theatre.

This was the impetus in early days; words like "outrageous" and "scandalous" came easily to the lips. But after the MTC had established itself, and after the others had followed in the 1960s, certain specific problems—you might call them second-generation problems—began to appear.

In 1962 the Shaw Festival, devoted to the works of George Bernard Shaw and his contemporaries, was founded in the lovely little town of Niagara-on-the-Lake, Ontario. The Charlottetown Festival on Prince Edward Island, featuring Canadian musical comedies, began in 1964. The year 1967, the one hundredth anniversary of Canada's birth, was celebrated in many cities by the building of ambitious theatres and cultural centres—the National Arts Centre in Ottawa was perhaps the most famous of these, and one of the most successful.

But there was never enough money. Theatre companies, encouraged by favourable

audience response, would schedule long seasons and tours. But these always, in one way or another, lost money. Professional theatre seldom or never shows a profit in Canada, or even comes close. Grants from government agencies, while steadily rising were never high enough. Financial crises were frequent.

Second, and more important, the theatre companies were accused of failing to develop Canadian talent. The playwrights, particularly, felt themselves neglected by the regional theatres, like the Neptune in Halifax or the St. Lawrence Centre in Toronto—or, for that matter, Stratford itself. The playwrights in the early 1970s were becoming an increasingly vocal and vigorous group, and they felt that most of the rich and successful theatres were settling too easily for American, British and European plays. These theatres, the playwrights argued, devoted far too little time to the much more difficult but also more creative process of working with and developing Canadian writers. At one point in 1971 a group of influential Canadian playwrights issued a manifesto demanding that *half* of all the plays produced in Canadian theatres be written by Canadians.

This became the great internal battle in Canadian theatre in the early 1960s, fought day after day in the newspaper columns, on television and radio, in the offices of the Canada Council, and in the theatres themselves. In a sense this ongoing battle was as important an event as the opening of Stratford in 1953 or the opening of the TNM in 1951. It signalled, as those events had, a new beginning.

In the end, the playwrights won the battle. By the mid-1970s they had impressed themselves on the regional theatres and festivals, to the point where the theatres and festivals were looking hard for Canadian writers. Stratford by then was promoting new Canadian playwrights, the Neptune Theatre was doing the same, so was the St. Lawrence Centre.

The battle was won not by argument but by talent. The playwrights, ignored by the established theatres, went off and proved themselves in the only way they could: by creating their own little theatres and demonstrating that their work was worth producing and worth seeing. They demonstrated this most clearly in the little theatres of Toronto, but they did it also in Vancouver, Halifax, Winnipeg, and Montréal. The process really didn't begin until the late 1960s, but by the summer of 1974 the issue had been so clearly decided that the federal Secretary of State, Hugh Faulkner, said in an interview: "What's going on in the smaller theatres today in Toronto and other cities is the most relevant, the most important thing that's happening theatrically in English Canada. More relevant in many ways than, say, Stratford."

There had always been original plays in English Canada. In the 1920s there were original plays regularly produced at Hart House on the University of Toronto campus. This died out with the Depression in the 1930s, but after the Second World War there were many attempts to revive original writing in the Canadian theatre. The Dominion Drama Festival, an annual event bringing together the country's best amateur theatre companies, occasionally included original plays. Robertson Davies was writing plays in Peterborough, Ontario in the 1940s and 1950s. The Crest Theatre, a professional company in Toronto

in the 1950s and 1960s, made serious efforts to encourage Canadian work.

But these were always *exceptions*. The writers involved and their audiences always knew that a Canadian play was somehow a freak, something special. In the early 1970s, this changed. Canadian writers, directors and actors began to accept it as normal that Canadians should write plays in the same way that Americans or Englishmen did. The 1950s made it possible for someone to call himself a Canadian actor and be considered a professional rather than an

amateur. The 1970s did the same for Canadian playwrights.

Two events in 1967, three thousand miles apart, hinted that a change was coming. One was the emergence of John Herbert in Toronto, the other was the emergence of George Ryga in Vancouver. It was no coincidence that they happened in 1967, because that was the year of new confidence in Canadian culture. Expo in Montréal that year was a success beyond everyone's wildest dreams. Because it was partly a festival of the arts it made people think about original Canadian

art—even in the theatre. The background was prepared for the emergence of our playwrights.

John Herbert actually was acclaimed in New York before he was recognized in Canada. His play, *Fortune and Men's Eyes*, opened there, off Broadway in February, with great success. Based on Herbert's own experience as a prisoner in the provincial reformatory at Guelph, Ontario, it was written with originality, bite and humour. In the fall of 1967 it moved with the original New York company to the Central Library Theatre in midtown Toronto. There it created an excitement unequalled in English-Canadian theatre since the opening of Stratford. Here was a play by a Canadian about a Canadian situation, and it was gripping and terribly beautiful. The audiences responded with great emotion, and in the theatre in those weeks of its run there must have been a good many would-be writers and directors, dreaming of a real Canadian theatre.

The same autumn, the Vancouver Playhouse staged *Ecstasy of Rita Joe*, by George Ryga, a Canadian writer previously known mainly for his work in broadcasting. The play was about a Canadian social issue, the treatment of Indians, and it starred Frances Hyland as Rita Joe and Chief Dan George as her father. The critic Don Rubin, who says we should "date the emergence of the Canadian playwright" from the opening night of that play, suggests: "*Ecstasy* was Ryga's rather wry Centennial gift to the Canadian people." Ryga was dealing with the dehumanization of life in western society, and in particular with the Canadian white man's inability to deal with the Indian's needs on the Indian's terms. There is a line at the end of the play: "When Rita Joe first come to the city, she told

me . . . the cement made her feet hurt.'' The contrast was between the natural life of the Indian and the cold inhumanity of city life.

Once again audiences were excited by a Canadian writer dealing with a theme close to home; the possibilities were opened up. In Toronto the little theatre movement was soon taking on fresh life. The Theatre Passe Muraille, which sprang from Rochdale College (an experimental, student-run college in midtown), began in 1968. At first it worked with American plays but soon it moved on to original Canadian works, and by the early 1970s it was creating plays in collaboration with audiences—for instance, by moving all the actors and writers to a farm community and developing a play out of the history and culture of the farmers.

The Factory Theatre Lab started in Toronto in the summer of 1970 with a humble little theatre over a gas station and a startling declaration of purpose: it would do *nothing but* Canadian plays. This statement was greeted with incredulity. Where would such plays be found? But Ken Gass, who ran the Factory Theatre Lab, found them. Within six months, in fact, he had found a really fine one—*Creeps*, a raucous comedy about cerebral palsy victims, written by a cerebral palsy victim, David Freeman. *Creeps*

was later to be produced in several Canadian cities and in New York and Washington, but in early 1971 it served a vital function for Toronto. Because it was so brilliant it drew audiences who had previously been unaware or sceptical. It made the new theatre seem important.

Later there were more theatres. The Tarragon Theatre, in part an outgrowth of the Factory Theatre Lab, emerged in 1971, also focused on Canadian plays, and soon came up with a remarkably successful play called *Leaving Home*, by a Newfoundland writer named David French. That dealt with the story of a Newfoundland family coming to grips with life in Toronto, an important social theme in recent Canadian history. Later, yet another important small company producing Canadian plays appeared in Toronto: the Toronto Free Theatre.

Soon Canadian plays began appearing elsewhere in the country — in Calgary, in Halifax, in Charlottetown. The activity in English was paralleled by a similar extensive activity in French. One distinguished young French playwright — Michel Tremblay, author of *Les Belles-Soeurs* and other works — bridged the gap between the two cultures by having his works appear in both English and French. In 1972 Canadian playwrights even got their own summer festival: Festival Lennoxville, Québec, began producing plays by writers like George Ryga, Robertson Davies and David Freeman.

By the mid-1970s, Canadian playwrights had become an everyday part of the culture of the country. They had still not reached mass audiences — except in rare television appearances — but they were now a force to be reckoned with.

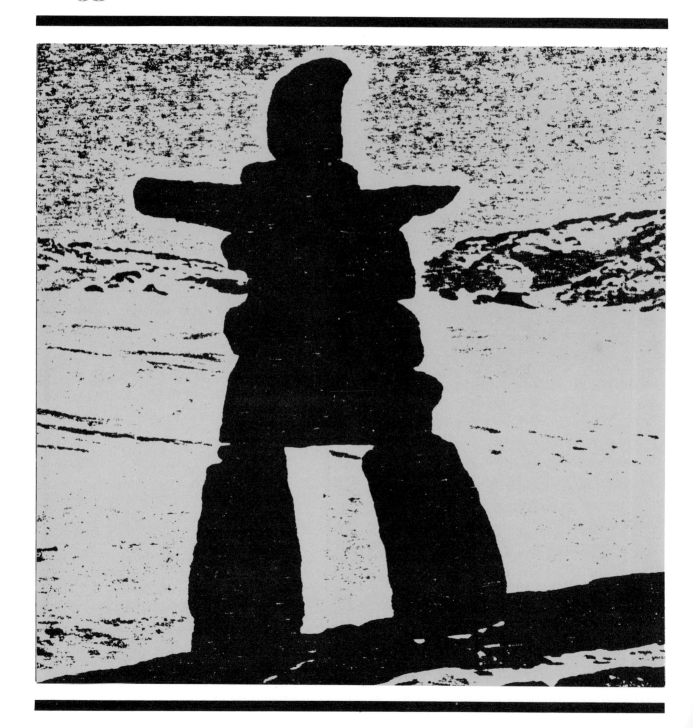

6 Make Way for Magic!

I am not going to pretend it is necessary for artists to be explorers, but it would create a lot more respect for the craft if artists brought back hard-won impressions of places where the going was tough.
— A.Y. Jackson, 1943

The most important statement ever made by a painter in Canada was contained in a little mimeographed booklet published in Montréal in 1948. The booklet was called *Refus global*, meaning "total rejection". The man who edited the booklet and wrote its crucial section was a painter and teacher named Paul-Emile Borduas. He was the leader of a group of artists called the Automatistes.

Refus global was a statement rejecting, on behalf of a new generation, the traditional ways of thought and art in the province of Québec. Borduas believed, along with many intellectuals and artists, that Québec life in that period was

stifling. What was needed was an intellectual explosion to shake Québec society to its foundations. *Refus global*, as Borduas and his friends saw it, would be an explosion.

Borduas wrote that Québec society was dominated by a conservative Church and an old-fashioned educational system. He saw personal liberation as the only hope for the future. He wrote:

> **Break permanently with the customs of society, disassociate yourself from its utilitarian values . . . Refuse to live knowingly beneath the level of our psychic potential . . . Refuse to be silent . . . Refuse to serve . . . MAKE WAY FOR MAGIC! MAKE WAY FOR LOVE! MAKE WAY FOR THE REAL NECESSITIES! . . . we will pursue in joy our desperate need for liberation.**

It is hard to imagine today the atmosphere in which *Refus global* was published and received. At that time modern art was widely believed to be communist or atheistic, and the Church and educational authorities looked with disapproval on artists like Borduas. When those artists went so far as to express themselves publicly in this way, they were inviting censure.

Borduas was then employed at the Ecole du Meuble, a design school. In those days he sold few of his paintings, and as a father of three he depended on his income as a teacher to support his family. But after *Refus global* appeared, he was fired. He received a letter a month after the publication which said that the minister of social welfare and youth of Québec had asked that he be dismissed, "because the writings and manifes-

toes he has published, as well as his general attitude, are not of a kind to favour the teaching we wish to provide for our students."

He was out of work, his teaching career ended, but the incident itself was not closed. In fact, it is not closed yet. With *Refus global*, as one commentator, Pierre Vadeboncoeur, has said, "modern French Canada began." If that is putting it too strongly then at least it can be said that *Refus global* was the first crack in the iceberg of Québec traditionalism. This was the first time a figure of distinction had challenged openly the dominant life style of the province. Someone with foresight might have seen in that little pamphlet all that was to come: the reformation of Québec politics, the transformation of the educational system, the tremendous outpouring of Québec culture in the 1960s and the 1970s. Borduas, for his part, became not an outcast but a hero to the rising generation. His fame as a painter spread, his influence on other artists increased. He became the first great post-war hero of Québec culture, the forerunner of Hébert, Jutra, Vigneault, Ducharme and so many others.

Borduas' now-famous gesture was a special event in the history of modern Canadian painting, but at the same time it was also typical of the way our painting has expressed the changing quality of our life. Again and again the visual artists of Canada — more than the writers, more than the theatre people or musicians or filmmakers — have both shaped and reflected the mood of the country.

In the 1920s Canada was coming to its first stages of self-consciousness as a nation. The people were reaching out in their imaginations, trying to grasp the true dimensions of the beautiful and almost incredible vastness they inhabited. The artists who typified this reaching-out were the Group of Seven, who tried in their painting to convey the nature of the Canadian landscape. In the 1950s and 1960s Toronto was becoming a metropolis, and for the first time beginning to see itself as a city on the world stage. It produced then two groups of artists — one gathered under the name Painters Eleven, one grouped around the Isaacs Gallery — who expressed the city's new internationalism in the way they drew on international art styles. In the late 1960s and early 1970s, Canada — but especially English-speaking Canada — was in the throes of another revival of nationalism, this time directed towards independence from the United States. Once more a group of artists arose, some of them centred in southwestern Ontario around London, who saw national expression as one of the chief motives of their painting. We can expect that whatever the mood of the 1980s or the 1990s, there will be artists who will give it visual expression.

But return to Borduas for a moment. He was born in 1905 in the little Québec village of Saint-Hilaire. That, by good fortune, was the home and working place of Ozias Leduc (1864-1955), a traditional painter of great skill and imagination. As a boy Borduas attended the local church and first knew Leduc's work through his church murals. Later he studied with Leduc, came under his influence, and became a church painter himself. As the critic Russell Harper has put it: "He received from the older man a 'spiritual atmosphere of the Renaissance.' From him Borduas learned dedication to artistic purpose and integrity." Leduc urged him to go to Montréal and attend the Ecole des Beaux-Arts.

Later he went to Paris and studied the modern French masters.

In the late 1930s, as a teacher at the design school, Borduas worked with some of the artists who were to become distinguished in later years. Among them were Jean-Paul Riopelle, who was to have a brilliant career in Paris in the 1950s and 1960s, and Marcel Barbeau and Jean-Paul Mousseau, both of whom would later be famous names on the Montréal scene. Borduas seems to have learned from his students at the same time they were learning from him; it was a period of mutual exploration and discovery. During the Second World War he and his colleagues developed Automatisme, the style that was to give Montréal painting in that period its distinctive flavour. Out of the atmosphere that they created there developed new generations of Québec artists–among them Guido Molinari, Rita Letendre, and Claude Tousignant, each of them a figure of distinct power and originality.

Borduas was influenced by the European and New York Surrealists. Their doctrine implied that each artist had within him certain unconscious forces which could be released onto the canvas "automatically," in a free flow of ideas. Borduas slowly adopted this method, bringing to it his own fine sense of colour and composition and his excellent training. The result was a series of canvases, executed over the next twenty years, which are among the finest in Canadian history.

In 1948 came *Refus global*. Years later Borduas was to say: "I don't regret it, because I discovered myself through that book." But at the time it caused him economic hardship. In the late 1940s and early 1950s he was never financially comfortable. He sold pictures occasionally, and taught art to children, but under economic stress his marriage collapsed. He began to be exhibited outside Québec: the Art Gallery of Toronto showed him in 1951, the National Gallery in Ottawa was buying him, and he made contacts in New York. In 1953 he moved to New York, where abstract expressionism much like his was flourishing. There he exhibited his work, and by 1954 was in the collection of the Museum of Modern Art. The following year he was back in Montréal, having made arrangements to sell his pictures through a Montréal and a New York dealer.

That year he moved to Europe, and he was never to return. He settled in Paris and began painting feverishly. Now he had many dealers and museums asking for his work, and he was working hard on the refinement of his art. He was homesick and lonely in Europe, but somehow he felt Europe was where he should be and he took consolation from his increasing reputation among European critics. In the late 1950s his work grew more and more simple: his canvases, particularly those in black and white, took on fresh strength and vigor. But the artist who made them was often ill, and in 1960 he died of a heart attack, at the age of fifty-five. Russell Harper has written: "The last canvas on his easel was totally black, like a curtain of mourning drawn down over a life of continuous searching."

All real artists are explorers: they go to the edge of what is known and report back. But the members of the Group of Seven, and their great friend Tom Thomson, were *literally* explorers. They went into the wilderness in their canoes and by foot, and they painted the real Canada that only a

few Canadians had seen. They went to northern Ontario, to the Rockies, to the Arctic, everywhere there was landscape that could provide the basis for interesting painting. And perhaps this single fact, that they were explorers, explains why they are so enormously popular and seem destined to remain popular for a very long time.

Their story has been told so often to Canadians – in school, in books, in magazine articles, in films and TV shows – that it has become the great myth of Canadian culture. In some ways it is to Canadians what the myths of ancient Greece are to the Greeks, or the Arthurian legends to the English or the stories of Paul Bunyan to the Americans.

The myth goes this way. A group of painters, early in this century, began to see the need for a distinctively Canadian art. All around them were established successful artists imitating the art of Europe. The Group of Seven artists, however, decided to paint Canada as it *really* was, not in terms of delicate European-style farms and gardens but in terms of rough and brutal landscape. They met with great opposition. The Art Establishment hated them, and so did the critics. The Art Establishment tried to stop them from exhibiting, and the critics piled scorn on their heads when they began to exhibit together in the 1920s. But they prevailed. Their art was so good, and so fresh, that it overcame all criticism and finally emerged as the great national style of Canada, revered by a grateful nation. By the 1970s it was bringing enormous prices in the art galleries and auction rooms.

Not all this is quite true. For one thing, the establishment was not nearly so hostile to the Group as the Group's friends sometimes say. The National Gallery, for instance, was a passionate supporter of the Group's members even before they became a group, and there were solid private patrons.

Furthermore, the critics were not all hostile. The members of the Group, particularly A.Y. Jackson, remembered the attacks but forgot all the encouraging things that were said. Most important, the Group's styles were not all entirely fresh responses to the Canadian landscape. The members of the Group, rightly, learned a great deal from European art and applied it to the Canadian settings they painted.

The vision of Canada they presented to Canadians – and, in some important international exhibitions, to Americans and Englishmen – was in some ways an idealized one. In the National Gallery there is a beautiful, dream-like painting by Lawren Harris titled *North Shore, Lake Superior*. Of this A.Y. Jackson has written:

> It shows a big pine stump right in the centre of the canvas and Lake Superior shimmering in the background. Among the members of the Group it was known as "the Grand Trunk". I was with him when he found the stump, which was almost lost in the bush; from its position we could not see Lake Superior at all. Harris isolated the trunk and created a nobler background for it.

That was one thing Group of Seven art conveyed: nobility, the grandeur of the Canadian outdoors. Through the eyes of the Group of Seven, Canadians acquired a new appreciation of the wilderness on their doorstep. And Cana-

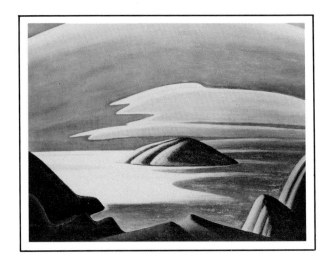

dians were suitably grateful. They took the Group of Seven to their hearts. No other artists in any field, before or since, have so deeply implanted themselves in the imaginations of Canadians. The last living member of the Group of Seven, A.Y. Jackson, was treated as a national hero—a Toronto school and a lake were named for him, children and adults made pilgrimages to see him, and newspapers wrote article after article about him. When he died in 1974, at the age of ninety-one, the country mourned.

Tom Thomson remains the most famous heroic figure in Canadian art, but his career was breathtakingly short: he began his really serious work in 1911 and by 1917 he was dead. Thomson, who was born near Toronto in 1877, was a commercial artist of modest distinction in Seattle and Toronto in the first years of the century, but the art he produced on his own was not of any special importance. In 1911, however, he was persuaded to go on his first trip to the Ontario north woods—to the Missisagi Provincial Forest

Reserve. There he began to make the first of the many sketches in which he was to leave a vibrant record of the northland as he saw it. From then until his death he spent every summer sketching and every winter converting his sketches into paintings.

During those years Thomson made close contact with many of the others who were to form the national school. He worked in a commercial art studio with J.E.H. MacDonald, who had been born in England and had come to Canada in his boyhood. In the same studio they met Arthur Lismer and Fred Varley, both English born, and Franklin Carmichael and Frank Johnston, who were born in southern Ontario. Thomson told Lismer about the northland, he held many long conversations about art with Varley, and he shared a studio with A.Y. Jackson, a Montréaler. In 1913 Thomson met Lawren Harris.

These men came together into a school. In later years it was clear that their styles were widely different, but at the same time they shared a common interest in the Canadian landscape and

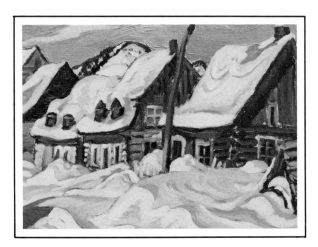

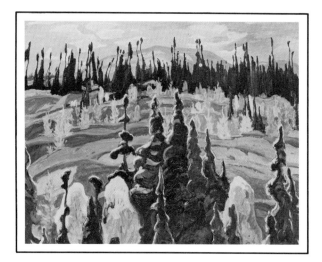

their leader (if anyone could be called a leader) was Thomson.

In those last few summers of his life he made Algonquin Park his home from early spring to late November. He not only painted it, he lived it. He learned to paddle a canoe with the skill of an Indian, and he fished with enormous skill. He worked as a guide for tourists and as a forest ranger. Then, in winter, he would be back in Toronto converting his small summer sketches into larger paintings. He abandoned commercial art so that he could give his time to his paintings, and he was constantly short of money. Before his death he managed to paint only about thirty large pictures. All those that survived are now among the most prized possessions in Canadian culture.

On July 8, 1917, Tom Thomson was seen leaving Mowat Lodge on Canoe Lake, Algonquin Park, for an afternoon of fishing at a dam nearby. Later that day his canoe was found overturned and empty; on July 16 his body was found. Ever since, his death has been shrouded in mystery;

because he was such an expert canoeist some of his friends have suggested he was murdered. But despite careful investigation, the mystery remains unsolved.

Thomson's death was a blow to the development of the national school. A.Y. Jackson, in a letter to J.E.H. MacDonald, wrote: "Without Tom the north country seems a desolation of bush and rock. He was the guide, the interpreter, and we the guests partaking of his hospitality . . ." Another, earlier blow was the First World War: it scattered the artists, taking some to Europe, and slowing their group development. But most of them resumed work in Toronto immediately after the war and by 1920 were ready to show as a group.

Their exhibition opened on May 7, 1920, at the Art Museum of Toronto (now the Art Gallery of Ontario). The Group of Seven were listed as Frank Carmichael, Lawren Harris, A.Y. Jackson, Frank H. Johnston, Arthur Lismer, J.E.H. MacDonald and F. Horsman Varley (later

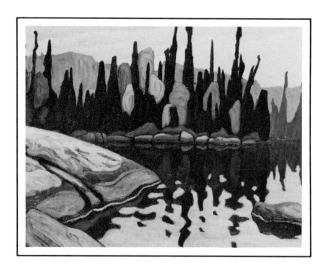

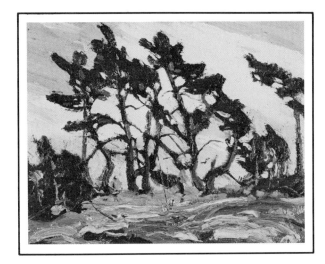

led against their influence. But more than half a century after that first show, they have not been displaced. There are no Canadian artists whose work is more widely revered and reproduced. The McMichael Conservation Collection of Art at Kleinberg, near Toronto, is a kind of shrine to their memory, and every year thousands of tourists go there to admire their work. For many people, the Group of Seven *are* Canadian painting.

In art, each generation rediscovers the idea of modernity. Each one rebels against the immediate past, each sets forth on what it believes is the true path to fresh vision. In Canadian art, each generation believes that it knows how to bring Candian art up-to-date. Certainly that's how the artists of the 1940s felt in Montréal at the time of Paul-Emile Borduas' Automatiste movement.

But Borduas and the Automatistes were not alone in their endeavour to bring modern art

Carmichael and Johnston gradually withdrew from the Group). Their catalogue declared: "The group of seven artists whose pictures are here exhibited have for several years held a like vision concerning Art in Canada. They are all imbued with the idea that an Art must grow and flower in the land before the country will be a real home for its people."

They existed as a small Group for only a decade – in 1931 they held their last exhibit together, and then expanded into the Canadian Group of Painters. As Jackson said in 1931: "The interest in a freer form of art expression in Canada has become so general that we believe the time has arrived when the Group of Seven should expand, and the original members become the members of a larger group of artists . . . " Their original defiant gesture was no longer revolutionary. They were accepted, and had become a part of history.

Since then they have often been attacked by critics, and generations of painters have rebel-

to Québec. Alfred Pellan, a towering figure, pursued separate but parallel lines as he fought a continuing battle with academicism. Through the 1940s and 1950s Pellan and Borduas were rivals for the leadership of modern art in Québec.

Pellan was born in Québec City in 1906, the son of a railroad engineer. He showed enormous promise in his early years and in 1922, when he was a sixteen-year-old first-year student at L'Ecole des Beaux Arts in Montréal, he had a landscape painting purchased by the National Gallery of Canada. His training in Montréal was traditional, and so was his art, but Paris changed all that. In 1926 he received a Province of Québec bursary to study in Paris. From that year on, Paris and French art and Alfred Pellan were closely linked.

His biographer, Germain Lefebvre, has described the impact.

> **The Québec artist never rejected his early training in his native city and constantly manifested his appreciation to his old teachers who were the first to suggest to him . . . the illuminations of art. But the revelations of Paris were something else! Paris was a true introduction to the sacred fire, the dazzlement of a transfiguration.**

In Paris, where he lived until war forced him home in 1940, Pellan made contact with some of the great figures of modern art—among them Pablo Picasso and Fernand Léger. He took from them, and from the pictures he saw in art galleries, a new sense of the possibilities of modern art. Pellan's skills had already made him a good realistic painter, but in Paris in the 1930s he moved on to surrealism. Occasionally he was to return later to realistic-looking art—as in his beautiful and eloquent portraits—but through the next four decades he established himself beyond question as the most important surrealist in Canadian history. In the mid-1970s he still holds that position.

His surrealism presents to the viewer imaginative dream landscapes populated by angels and devils. Maurice Gagnon, in a 1943 book about Pellan, summed up Pellan's view of painting in these words:

> **Pellan knows of and desires the presence of his angels and monsters who multiply, rise and destroy themselves in him, which impose themselves on us with the inescapable force of enigmatic beings from whose toils there is no escape for their prey. Pellan's world is a world which follows us, which haunts us until it conquers us.**

But there was also another side to Pellan's art, a series of outbursts of gaiety and joy.

Pellan brought some of the insights of Paris—and some of its teaching methods—back to Montréal when he returned in 1940 and began teaching at L'Ecole des Beaux Arts. He fought with the other teachers there, publicly and privately, as he tried to give individual students much more independence and at the same time inform them of the art world beyond Québec's border. He lost some of the battles but his generation in effect won the war. Modern art became a part of the fabric of Québec life, Pellan became a figure of veneration. In 1960 the National Gallery

of Canada gave him a retrospective exhibition. Meanwhile, back in Paris, private dealers and public museums continued to treat him as a figure of consequence. In 1955 Le Musée d'Art Moderne of Paris gave him a one-man exhibition, making him the first Canadian ever honoured in this way.

Just as Borduas and Pellan in their different ways brought internationalism to Montréal in the 1940s, so two other movements brought in-

ternationalism to Toronto in the 1950s. But while the Montréal artists imported French ideas, the Toronto artists brought to their own home city—and to English Canada as a whole—the American doctrine of abstract expressionism.

In Toronto the movement began with the group that called itself Painters Eleven. They never had a permanent home, they seldom agreed among themselves on aesthetic principles, and they lasted only to the end of that decade, but their reputation was enormous and the results of their work lasted long after they disbanded.

J.W.G. (Jock) Macdonald and Jack Bush, both mature and experienced artists, and Harold Town and William Ronald, who were both to become major figures in the new generation, were among the Eleven. In 1953 Jock Macdonald was a teacher at the Ontario College of Art, where Ronald had recently been a rebellious student. Bush and Town earned their living by commercial art.

What they all had in common was a dedication to the principles of non-objective art; that is, painting without subject matter. Macdonald, who had studied with the great German-American artist Hans Hofmann, was a kind of father figure to the group, and before his death in 1960 he produced some of the finest non-objective pictures in Canada. Jack Bush was not seen by most critics and observers as a major figure in Painters Eleven, but in fact he emerged in the 1960s as the only English-Canadian painter with a genuinely international following and reputation: his vibrant canvases came to be as popular in London and New York as they were in Toronto. William Ronald went to New York in the 1950s and enjoyed some success, then re-

turned to Toronto and became better known as a radio and television broadcaster than as a painter.

Town was a separate case. In his time he has been the most admired of Canadian painters, and the most criticized; at times he has been unjustly neglected, at times praised for the wrong virtues. The reason is not hard to find: his talent is so prodigious that almost no one can grasp all of it. He has done paintings, drawings, prints, sculpture, posters, illustrations—and he has done all of them with an exceptional skill, in a brave and heroic and outgoing style that leaves many art lovers speechless.

Most artists limit themselves to one or two styles but Town, in any given year, may work within half a dozen or more. He has done some of the most impressive of non-objective paintings,

but he also often works with subject matter. In his imagination he dashes back and forth across history—he is as likely to draw an ancient Greek warrior as a modern pop music star. He allows himself to be influenced by dozens of historic figures and styles, from pre-Columbian Mexican art to the paintings of Rembrandt. One art scholar, David Silcox, has written: "There has never been another Canadian artist with his range of knowledge, his virtuosity and natural talent, his subtle sense of place in his environment and in history, or with his endless fertility."

Town is also a controversialist, a personality on the public scene. He writes biting magazine articles and book reviews, appears on television, issues statements to the press. He has appointed himself a kind of Duke of Art in English Canada,

and he plays the role with great style and versatility. In Harold Town, painting has given to modern Canada one of its grandest personalities.

In the 1950s, while the Painters Eleven artists were hard at work, another art movement was under way in Toronto. This movement was even more loosely knit than Painters Eleven, and it had no formal name, but it was to last longer as a group—well into the 1970s, in fact. It was the movement that clustered around a gallery opened in 1955 by art dealer Avrom Isaacs. In the beginning it was called the Greenwich Gallery; later, when it shifted location, it came to be known as the Isaacs Gallery. If English-Canadian painting in that period had one physical home, that was it.

The painters there, like the Eleven, were deeply influenced by American painting. But each of the dozen or so artists who emerged as important had a distinctly personal style of expression. Michael Snow in those years worked in a brittle, tough manner that seemed always to be out at the edge of artistic experimentation; Graham Coughtry produced canvases of great sensuous beauty; Joyce Wieland developed intensely erotic themes; Gordon Rayner worked in a manner that was richly romantic. These artists—among the others were Dennis Burton, Robert Hedrick and John Meredith—knew each other well, exchanged ideas and impressions, and developed as a group. They made music as well as art: the Artists Jazz Band emerged out of the Greenwich/Isaacs scene, and by the 1970s even managed to make recordings.

Michael Snow, who was born in 1929, was the central figure in this group, and his pre-eminence was still clear in the mid-1970s. He was the inspiration for a whole generation of artists, and in some ways he became the centre of a cult. He is not only a vastly talented painter but also a filmmaker and a jazz pianist of exceptional ability. Snow is a kind of total artist: at one point he described himself as "doing music and painting and sculpture and various other things that are very hard to name."

Snow has now been accepted for a long time as a major figure in Canadian painting, but in his early years his art was generally rejected. He developed in his twenties a peculiar ability to make each painting a fresh start: sometimes a whole show of his pictures would seem to be the work of a dozen different artists and only the most careful examination would reveal that there was one painter behind all of them.

In the 1960s Snow developed the *Walking Woman* series, a huge collection of paintings based on a single outline of a walking woman. For about seven years he painted little else, and yet the variations he worked on this one theme were endlessly fascinating. They culminated with paintings and sculpture shown at Expo '67, where Snow was among the most impressive artists in a vast international gathering of art.

Snow and his wife Joyce Wieland both turned seriously to filmmaking when they lived in New York in the 1960s—and both have since enjoyed outstanding success in that field. Snow's film *Wavelength* has won international prizes and been praised by critics in several countries. In the first half of the twentieth century, most of the serious painting activity was focused on Montréal and Toronto, as it had been in the century before. There were important exceptions:

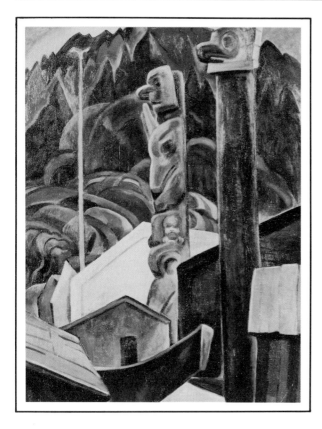

that people in B.C. have for the wilderness around them.

Vancouver was the beginning of the spreading-out of Canadian art, and the trend was to continue. In the 1960s Regina also became an art centre. There painters like Kenneth Lochhead, Ronald Bloore, Arthur McKay and Roy Kiyooka came together in the development of certain common methods of abstract painting. They rejected the thickly painted abstract pictures so popular in Toronto and Montréal and turned instead to a thin, flat sort of painting—the kind of painting that a leading American critic dubbed *post-painterly abstraction*. All of them won national recognition; some were also shown outside Canada.

In London, Ontario, also in the 1960s, a nationalistic movement of painters grew up around Jack Chambers and Greg Curnoe. Curnoe expressed, in his art and in what he said, the theory that art should spring from the immediate surroundings of the artist. Curnoe painted his own family, his house, the view from his studio window, his bicycle. To know his art is to know a great deal about him. Chambers and Curnoe were also leaders in a national artists' union, Canadian Artists Representation, which sought a larger place in Canada for the work of Canadian artists and expressed a point of view that was nationalistic and anti-American.

From the 1950s to the 1970s most of the artists who made large reputations across Canada worked in some form of abstract art: they were not notably devoted to subject matter, as the Group of Seven and its predecessors had been. But at the same time there was a continuing tradition of realism, and this often produced first-

for instance, Emily Carr (1871-1945) in the first decades of the century produced, in British Columbia, paintings that made her one of the towering figures in modern Canadian art. But for the most part painters (as well as dealers, collectors, museums and art societies) were clustered in the eastern cities.

The second half of the twentieth century changed all that. Vancouver became an art centre of great importance in the 1950s with the work of artists like Jack Shadbolt and Gordon Smith. Their art reflected the magnificent British Columbia landscape and expressed the special feelings

rate art. Sometimes it was called *magic realism*, which meant realism taken to such a point of accuracy that it seemed to carry a charge of almost supernatural force. Later it was called *high realism*. In any case, it was a persistent element of importance in Canada, and seems particularly to have taken root in the Atlantic provinces. Alex Colville in New Brunswick and Christopher Pratt in Newfoundland were two of the artists who carried it to the highest level.

A large part of Canadian painting, including the Group of Seven's work, appeals to viewers because of its subject matter as well as its artistic qualities. In this category the most famous Canadian artist of the generation now at work is William Kurelek—a realist who has been called a primitive artist.

Kurelek was born in Alberta, of parents who came from the Bukovina province of the Ukraine. He grew up on farms they owned in Manitoba. On the Canadian prairies in the Depression of the 1930s, the Kureleks, like many of their neighbours, were desperately poor. But Ukrainian tradition was maintained, and Kurelek grew up absorbing it in his soul. He had a tortured young manhood that included a stay in a

mental hospital in England, a suicide attempt, and finally a conversion to Roman Catholicism that gave him for the first time a sense of purpose. But when finally he settled down in Toronto in the 1960s, and began to become one of that city's most popular and celebrated painters, he turned back to his Ukrainian-Canadian childhood for some of his subjects.

Everything that Kurelek paints is a desperately sincere statement. Often it adds up to saying: This is where I came from and this is what it was like. He presents the Ukrainian prairie culture of his boyhood not in easy and sentimental terms but in a blunt and straightforward manner. Those were desperate years for his people, and their desperation shines through many of his pictures.

Green Sunday, painted in 1962, for instance, shows the spring custom of bringing

branches of poplar trees into the house to be placed in all corners of the living room. It shows a woman posing in the traditional Ukrainian costume and a man playing an accordion. "These are happy memories," Kurelek has said of this picture. But the picture itself is solemn. In 1966 he painted *A First Meeting of Ukrainian Women's Association in Saskatchewan*. He shows this event from the 1930s not as an occasion for jubilation but as a rather difficult and even melancholy evening.

 The meeting room is small, but it is still too large for the handful of women gathered there. They are involved, Kurelek makes clear, in a hard task. They are trying, against the odds, to keep alive a light that means a great deal to them. The picture touches the roots of loneliness and ethnic isolation in the Canadian West. It suggests why so many Ukrainians go away from exhibitions of Kurelek's art with tears in their eyes.

There are far more paintings than sculptures in both the art galleries and the homes of Canada. Sculpture has not, until recent years, flourished here—except among native peoples. There was no equivalent in sculpture of the Group of Seven, and no equivalent of the Borduas movement either.

 One reason was cost: making sculpture costs far more money than painting pictures, and for most of Canadian history there was no money to pay for it. Another reason was public indifference: abstract painters can paint in private and then bring their work out to the public, but sculptors need commissions from government and business. For many years there were few or no commissions. (The only time when there were

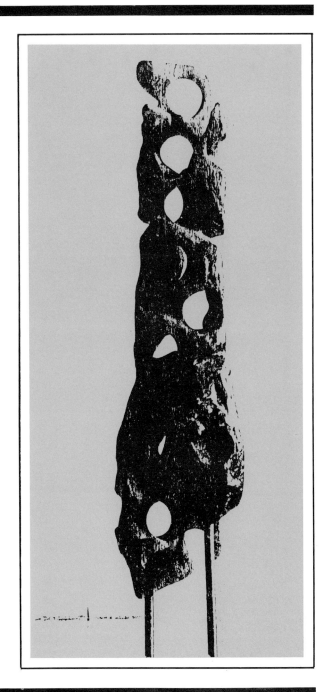

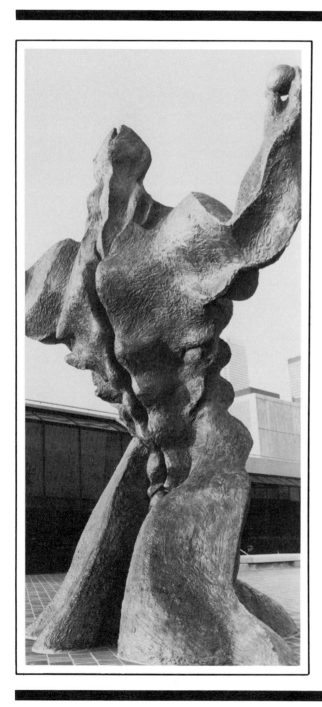

many sculpture commissions was just after the First World War, when many towns erected war memorials in stone or bronze.) A final reason was the isolation of Canada. A young Canadian artist might examine great drawings and paintings in books, but sculpture must be seen in the round. In the days before the Canada Council, when there were no travel grants, it was hard for artists to go where sculpture was to be seen.

Finally, in the 1960s, Canada grew prosperous enough to afford sculpture. Government commissions began to appear, and some private sales as well. Gerald Gladstone in Toronto and Armand Vaillancourt in Montréal brought the new styles of abstract sculpture to the art galleries of those cities. Robert Murray, a native of Vancouver, spent most of his career in the United States but sent home some of the most distinguished sculpture of the period – including two major sculptures in metal that became the centre of controversy when they were erected in Ottawa in 1973. Murray worked in smooth, clean, stylish lines; he was to sculpture what artists like Jack Bush and Kenneth Lochhead were to painting.

In painting almost all the dominant figures of the last half century have been born or raised in Canada, but in sculpture immigrants have played a major part. These have included Kosso Eloul (who came from Russia via Israel), Sorel Etrog (who came from Rumania via Israel), Yosef Drenters (who came from Belgium) and Arthur Handy (who came from New York). This is one of several artistic fields which have been enriched by recent immigration.

In terms of modern sculpture, Canada in the 1950s was a wasteland. Now it is much better than that. Here and there in the cities you can see

evidence of first-class artistic talent at work – Kosso Eloul's sculpture on the Kingston, Ontario waterfront for instance, or Robert Murray's work at the Vancouver airport and the Pearson Building in Ottawa. In the 1960s and the 1970s, modern sculpture finally arrived in Canada.

Art in Canada, as it spread out geographically, also became more diverse. The art currents carried from America and Europe swept across the country, producing environmental art (sometimes whole rooms created by one artist), or correspondence art (art carried on through the mails) or earth art (natural forms, like hills or small rivers, reshaped by an artist). In Vancouver Iain Baxter worked inventively with plastics. In London, Ontario, Murray Favro created beautiful little rooms of art by combining real objects with films and slides. In Toronto Robin Mackenzie made a kind of natural art in which growing plants were part of the art objects.

By the time all this was happening, in the early 1970s, it was no longer possible to think about Canadian art as a few isolated schools in a few cities. Artists were moving off in a hundred different directions. A book published in 1974 claimed that there were then 10 000 artists in Canada and that 2 700 of them had exhibited in the previous year.

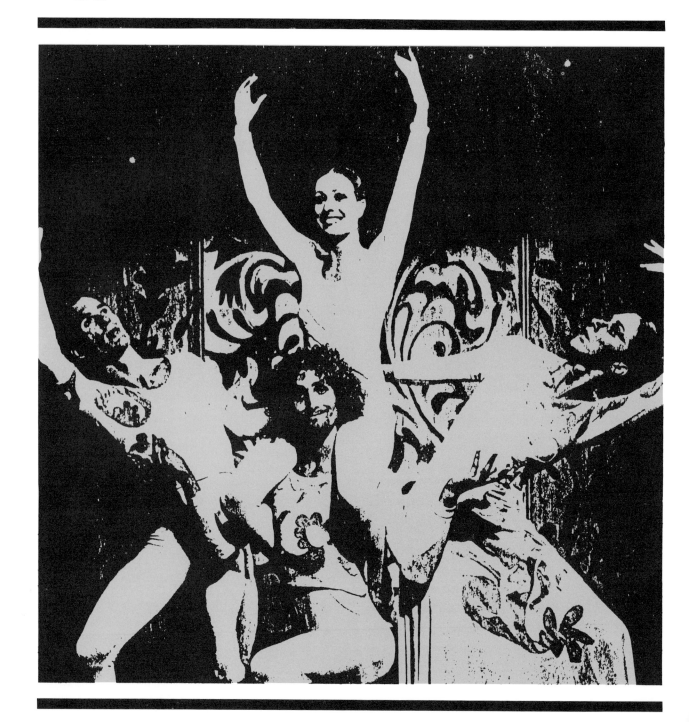

7 Years of Crisis and Triumph

Moscow, Dec. 16, 1968 — (CP) — The Royal Winnipeg Ballet left Moscow yesterday for Czechoslovakia following a final appearance of its tour in the Soviet Union Sunday night marked by wild emotion inside the theatre and turbulent scenes outside.

When the final curtain came down at the 2 000-seat Operetta Theatre in downtown Moscow, the Canadians were called back for an estimated 20 or more curtain calls while the audience yelled bravos and threw bouquets and personal notes on stage to the performers ...

Of all the artistic flowers which have flourished in Canada, ballet is one of the most difficult and delicate. The seeds of a ballet company must be planted with great care and the growing plant itself must be nourished lovingly—and the same is true, perhaps even to a greater extent, of modern dance. Canada, a few decades ago, had almost no tradition of ballet or modern dance, and no hope of getting one. Yet by the mid-1970s Canada had three remarkable ballet companies: Les Grands Ballets Canadiens of Montréal, the National Ballet Company of Canada (based in Toronto), and the Royal Winnipeg Ballet, as well as a flourishing collection of modern dance companies spread across the country. Each began in the most modest way, with only slight promise. Yet each of the ballet companies has grown into an organization of considerable stature, each has developed its own dancers and ballets, each has played to enthusiastic audiences both in Canada and abroad.

There is something more they all have in common: they were started by immigrants to Canada. Ludmilla Chiriaeff, who came from Latvia and had Russian and Polish parents, started Les Grands Ballets Canadiens. Celia Franca, who came from England, started the National Ballet. And Gweneth Lloyd and Betty Hey Farrelly, also from England, started the Royal Winnipeg. In all cases the leadership of the companies eventually began passing to native Canadians, in some cases to Canadians trained by the companies themselves. But there was never any doubt about the beginning: the impulse came from outside. Ballet began as an aristocratic art nourished at the courts of Europe, and it was Europeans who brought it to Canada and made it one of the most

popular of the performing arts in this country. The process has not been easy.

Ludmilla Chiriaeff arrived in Montréal in 1952. She and her husband and children were refugees from Europe; she had Swiss, German and French ballet experience behind her, but she had no connections in the new world. She hoped to start afresh, but she did not know how this could be made to happen. She has often told the story of her first night in Canada:

> **We decided to walk up from the station to the hotel. We were crossing St. Catherine Street and blazing on the marquee of the Cinéma de Paris was my name in lights. It was a film I had made of dance some time before in Paris. For me, it was an intense experience and an omen. I knew Montréal would be my city.**

So she was known, at least a little, in Montréal. Soon a producer at Radio-Canada's television service who had seen her work in the little French film introduced her to Canadian television. She was asked to a do a series of half-hour television programs, and she cast about for dancers. She found she had to train her own, so she was soon operating a school with sixty pupils and using her pupils on television. Together they made more than four hundred television appearances, and in the middle 1950s they began performing on stage. First they were Les Ballets Chiriaeff. Then, beginning with a performance in 1956, she rechristened her company Les Grands Ballets Canadiens.

It was a bold move: the company wasn't,

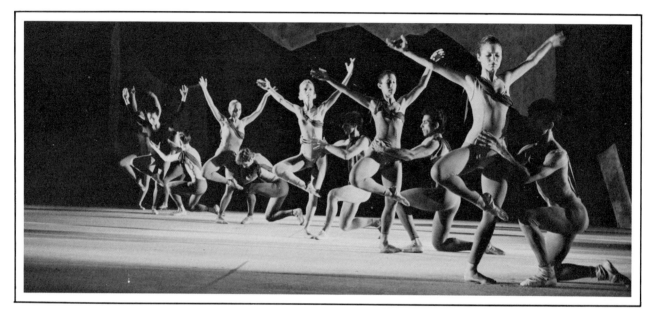

after all, very grand. In the early 1970s, looking back on that period, she reminisced:

> You know we had to take a lot of abuse for calling ourselves grand, but we knew what we were doing. Of course we weren't very grand when we started, but the name expressed our faith and optimism in the future. That's what people failed to understand–our survival here is a miracle and so is our growth–I think our achievements have been very grand indeed.

Survival. Miracle. These are words that run through the history of Canadian ballet in all its forms. In 1967 Nathan Cohen wrote in the Toronto *Star*: "For Les Grands Ballets Canadiens to last this long . . . is an achievement to be acknowledged, analyzed and pondered." In the early years the company lived on a shoestring and occasional modest grants, the first one from the city of Montréal, later ones from the Canada Council and the province of Québec. In the 1950s it ran only short seasons but the ballets were chosen with audacity. Even at the very beginning, Madame Chiriaeff dared to put on productions of exceptional grandeur. In 1956, at the Montréal Festival, she staged Stravinsky's *Les Noces*, a cantata-ballet, giving it the first North American production it had had since 1936; the critic of the Montréal *Gazette*, Thomas Archer, reported that this version with "soloists, choir and an orchestra of pianos and assorted percussion instruments turned out to be one of the most exciting events I have attended in the theatre within memory."

For Les Grands Ballets Canadiens, the

great event of the early 1970s was *Tommy*, an original ballet based on a rock opera by Peter Townshend and The Who, an English group. *Tommy* was a sort of minor revolution in the ballet, because it united the music of the young with the most classical of the performing arts in a unique way. *Tommy* is the story of a young man who is made into a deaf blind mute by the shock of seeing his father kill his mother's lover: he is miraculously cured and becomes a messiah. The story and the super-charged Townshend music made a dramatic ballet that electrified audiences wherever it played. Fernand Nault's choreography was not universally admired by the critics, but the production as a whole brought a new sense of urgency to ballet and drew younger audiences than any ballet company had known in years. Les Grands Ballets Canadiens toured the United States with a great success and in Toronto — at *Tommy's* opening night in the O'Keefe Centre — an audience of 3 200 rose to its feet at the end and cheered wildly. *Tommy* was the first ballet ever to break through to really large audiences.

In 1974 Ludmilla Chiriaeff announced her resignation as director of Les Grands Ballets, eighteen years after she started it. She would stay on as founding director and would oversee the various dance academies in Québec attached to Les Grands Ballets. Leadership of the company would now pass to Brian Macdonald, a Canadian-born choreographer who had directed the Royal Swedish Ballet and the Harkness Ballet in the United States and worked for the Royal Winnipeg Ballet and the Paris Opera Ballet.

But Ludmilla Chiriaeff left her monument. Moving in from Europe, with an art form most

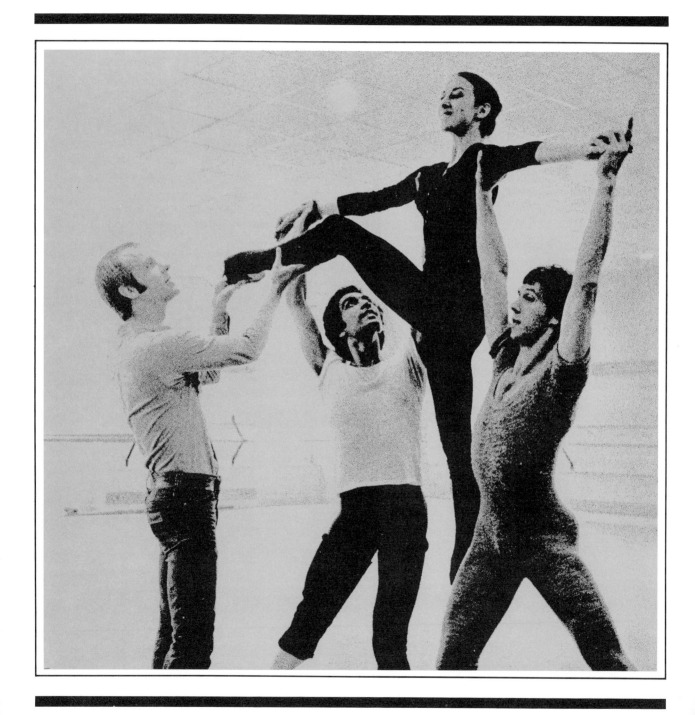

Canadians then found foreign, she had become a part of Canadian culture. John Fraser, then the Toronto *Globe and Mail* dance critic, said of her in 1972: "Madame Chiriaeff's influence on dance in Québec is pretty well all-pervasive. She is the single leading luminary and she has adopted the particular mystique of her adopted land with a great passion. In a sense, she is more French Canadian than the French Canadians." In 1969, talking of her relationship with the company, she said: "I was here first, and created the ballet company . . . In a special way, it is still my ballet company." There were those who felt it always would be. As the prime minister of Québec, Daniel Johnson, said to her publicly at an anniversary performance in 1968: "In the twenty-first century, after you are gone, they will say it is to you that Québec owes the ballet . . ."

In January, 1954, the National Ballet Company of Canada was on tour in Montréal. It was then just two and a half years old but already it had outdistanced itself: already it was spending more money that it could take in, either in box office receipts or donations. The director, Celia Franca, declared to a reporter: "We are at the crossroads. There is one word to describe our future and the word is 'grim'." A sum of $50 000 was needed, immediately, or the company would go under. Miss Franca announced that she would appear on stage at intermission in the performances and plead for money to go on.

The money was of course found, as other sums of money would on other occasions be found, but that statement was a kind of symbol of the early days of ballet in Canada. It is not easy now to balance the books, even in the days when the National tours America and Europe, and col-laborates with great stars of the international ballet world like Rudolph Nureyev, Erik Bruhn and Edward Vilella, when there are arts councils offering grants and great American impresarios offering contracts. But in the early days it was close to impossible.

The National Ballet began in the minds of three Toronto women, patronesses of the arts, who believed that Canada should have a full-scale ballet company. In the late 1940s the North American tours by the Sadler's Wells Company from England – later renamed the Royal Ballet – had aroused Canadian interest in the art. There were audiences with at least a little interest in the ballet, and there were good Canadian dancers turning up here and there – but most of them had to go abroad to practise their art. The three Toronto women, seeking advice, journeyed to England and sought out Ninette de Valois, one of the leaders in British ballet. She suggested that they hire Celia Franca, whom de Valois regarded as one of the great dramatic dancers in England and potentially a great leader. Miss Franca came to Canada in 1950 and looked over the available talent at a national ballet festival in Montréal. She was, according to reports, not impressed. But her urge to spread ballet, to make it take root in fresh ground, overcame whatever misgivings she may have had. In 1951 she moved to Toronto; and that same year the National Ballet was born.

At the beginning it was slightly more National than Les Grands Ballets was grand. It had no immediate plans for a national tour and it had no backing from the federal government, but at least its members represented many parts of the country. Miss Franca crossed Canada to audition talent and brought in dancers from Winnipeg,

Edmonton, London, Vancouver and elsewhere. There were dancing schools across Canada, then, of varying quality, and there were small amateur groups. From these Miss Franca assembled her first company. She brought them to Toronto and began teaching and then rehearsing them in the summer of 1951. At Eaton Auditorium in Toronto, on a stage of extremely modest proportions, she gave her first performance of the National. That was on November 11, 1953.

The ballets or parts of ballets that night included *Les Sylphides, Salomé, Giselle*, and the Polovetsian Dances from *Prince Igor*; there was also an original ballet by Kay Armstrong of Vancouver. The pattern for the National was thus set: a strong concentration on classical ballet, with a sprinkling of original work. The dancers on stage that night included Lois Adams, David Smith, Grant Strate and Earl Kraul—names that were to be important in the National's history for years to come. The star of the evening was Celia Franca, who was to dance with the National as well as guide it for many years. The critic of the Toronto *Globe and Mail* reported: "Her fine aquiline face and strong sense of drama as much as her dancing made *Salomé* live." Miss Franca's memories of the evening's performance were not ecstatic—"bloody awful" she called it years later. But that night there was a new leader in the arts in Canada, a leader who was to take on added significance as the years passed, whose influence would be felt for decades to come.

Within two years the National Ballet had moved into a proper theatre in Toronto (the Royal Alexandra) and had become truly national by touring the country. It had also made the first of many appearances out of the country—this one at the Jacob's Pillow dance festival at Lee, Massachusetts. There one of the most celebrated of American dance critics, Walter Terry, declared it "a dance company which boasted the eagerness of youth, vitality, discipline, admirable stage deportment and a great deal of maturing talent."

Dancing demands a strong sense of personal discipline at any time. In those days it also demanded enormous financial sacrifice. Most members of the company in the mid-1950s were receiving only forty-two dollars a week while rehearsing and an extra five dollars a week while on the road. When the company didn't need them they lived on fifteen dollars a week in unemployment insurance. A 1955 *Maclean's* magazine article gave an idea of the National Ballet dancer's life in those times:

> Young Yves Cousineau, a slender, twenty-two-year-old *Canadien* dancer, is one who ekes out his between-engagement periods on unemployment insurance. He manages it by paying seven dollars a week for a room which he shares with another, and by cooking all his own meals. The two dancers spend eight dollars a week between them on cheap meats. The rest goes for bread, milk, vegetables and carfare. Cousineau buys no clothes in the summer, stays away from barbers for six-month stretches, does all his own washing, takes his lunch to ballet school, sees no movies at all and spends his holidays eating bologna sandwiches on the beach at Toronto's Centre Island.

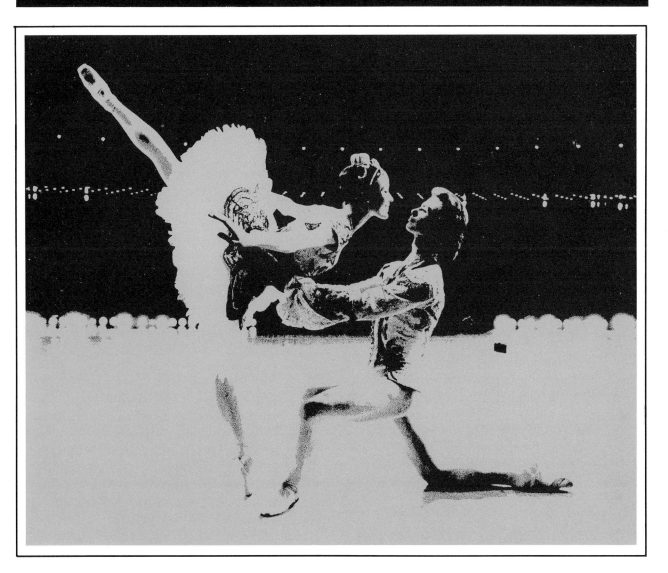

Those were the 1950s, the pre-Canada Council days, when the country as a whole had not yet seen fit to support the performing arts. By the 1970s the National Ballet's dancers were still not eating caviar regularly, but their company was on a sound financial basis and was recognized as a corps of distinguished and disciplined dancers. The ballets in its repertoire – including John Cranko's *Romeo and Juliet*, Erik Bruhn's *Swan Lake*, and Rudolph Nureyev's *The Sleep-*

ing Beauty – were acclaimed in Canada and abroad. In 1969 the National Ballet opened the new National Arts Centre in Ottawa with the first performance of Roland Petit's *Kraanerg*, a modern ballet commissioned for the occasion. In 1970 it was the only classical dance company invited to the World's Fair at Osaka, Japan. In 1970 its *Cinderella* won an Emmy Award as the best production of its kind shown on North American television.

The National's greatest problem, as it moved towards the end of its first quarter-century, was a lack of choreographers. It could revive the great classics of the repertoire, it could borrow choreographers from elsewhere, but so far it could not produce distinguished choreographers of its own. In this it was not alone. James Kennedy, an English critic for the *Guardian*, wrote in 1972: "So these Canadians do not have their own choreographer, a deficiency which they share with most other companies. But few other companies can provide as much compensation as this one can by the uniform efficiency and distinctive personality of its dancing."

What the National had, above all, was substance and authority; and it acquired this over the years by the painstaking process of training its own dancers. In 1959 it created the National Ballet School in Toronto, where adolescents can study both academic subjects and ballet at the same time. The school was so successful, and so much admired by visiting ballet teachers and directors, that its director was invited to Stockholm to reorganize the Royal Swedish Ballet's school along the same lines. By 1973 no less than four of the National Ballet's six ballerinas had received all of their training at the school and this was true

also of the leading male dancer, Frank Augustyn. Celia Franca had accomplished what she set out to do: she had created not only a ballet company but also a tradition of ballet.

But why should there be ballet in Canada at all? And why should there be ballet – distinguished ballet, original and brilliant ballet, world-famous ballet – in Winnipeg? The question has been asked often, by people both inside and outside Winnipeg. In 1949, when the Winnipeg Ballet was only a decade old and still amateur, it was already considered something of a miracle. "There is almost a fairy-tale quality about the success of the Winnipeg Ballet," wrote a contributor to *Canadian Forum* in 1949. He described Gweneth Lloyd's contribution as creator of the company and went on:

> Miss Lloyd did not come to the Western prairies to break virgin soil with a hand-plough and a team of oxen--an achievement carried out in our not-so-distant past. She did an infinitely harder piece of pioneering. She made out of nothing and sold to the people of Winnipeg, Manitoba (a city whose motto is 'Commerce, Prudence, Industry' and whose escutcheon displays one buffalo, one locomotive and three sheaves of wheat) the Ballet: a traditional, glamorous, sophisticated, complicated art-form. Winnipeg loved it.

This wondering tone continues to show up in much of the writing about what is now – as it has been since it was renamed in 1953 – the

Royal Winnipeg Ballet. In 1968 the influential ballet critic of the New York *Times*, Clive Barnes, came to Winnipeg to see the company on its home grounds. "Why here, of all places, should there be a ballet company?" he wrote.

Perhaps the answer is as simple as this: opposites attract. Bleakness in landscape and climate cries out for style and glamour, and for human expression carried out in this most physical and sensual of the performing arts. Canada in this sense is as natural a home for ballet as Russia; and in Canada, what city could be a better candidate than Winnipeg?

This was not obvious, of course, when Gweneth Lloyd and her partner, Betty Hey Farrelly, arrived there in 1938 from England. Miss Lloyd was teacher, organizer and choreographer; Betty Hey Farrelly was ballet mistress and dancer. Together they put advertisements in the paper to find dancers and began to teach them. For years the company was entirely amateur. Most of its members earned their living as teachers or clerks or stenographers, and worked at ballet only part-time. It was only in the late 1940s that it assumed professional status. But this fact never prevented Gweneth Lloyd from experimenting. She plunged into original ballets, commissioned original music for the company, and told her dancers they were part of a great pioneering effort. This would not be simply classical ballet transferred to the Canadian West—this would be ballet that came *out* of the Canadian West, with Canadian themes and (perhaps, someday) an original Canadian style. She wanted (Miss Lloyd later explained) to appeal to people who had never seen ballet—because, in fact, few European or American companies had ever reached Winnipeg and

there were only a few ballet movies available. So in her first five years she created twenty-one original ballets, returning again and again to themes that might interest her audience. One ballet was called *Kilowatt Magic;* it was an account, in dance, of the development of electric power in Canada.

In 1949 the Winnipeg Ballet began seriously touring Canada. In 1951 it gave a command performance before Princess Elizabeth and Prince Philip during their tour of Canada. The royal couple's tour was one of the great public events of that era in Canada and the fact that they viewed a Canadian *ballet* company made headlines across Canada and around the Commonwealth. The Winnipeg was now on the map in a way it had never been before.

The 1950s brought both success and disaster to the company. It began touring extensively in the United States for the first time, but in 1954 a fire in the company's headquarters almost ended ballet in Winnipeg. It destroyed everything the company owned: sets, music, costumes, equipment, even the clippings books. The period of revival was also a period of transition in the leadership of the company. Lloyd and Farrelly moved out, to be succeeded by two artistic directors who both had brief tenures. The company's future, for a year or two, looked bleak.

What saved it was the appointment, as director, of Arnold Spohr, the first native-born Canadian to direct a professional ballet company. He was the son of a Lutheran minister, born in Saskatchewan and raised in Manitoba. He had once set out on a career in physical education and had gone to Gweneth Lloyd for instruction in everyday ballroom dancing. She saw his potential

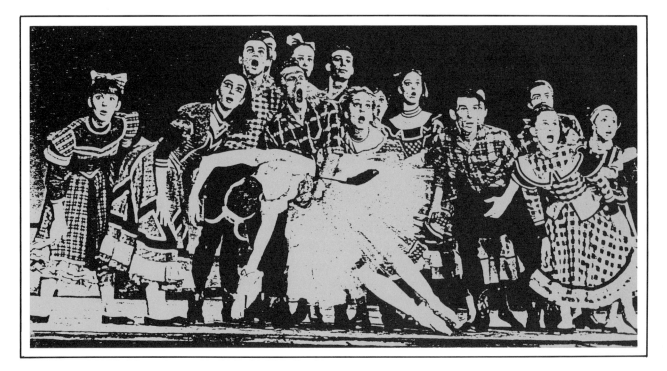

and persuaded him to become a ballet dancer. He worked with the company in the 1940s and 1950s, studied abroad, and was ready in the late 1950s to move into the leadership of the Royal Winnipeg Ballet.

Since then the company has moved from success to success. It regularly tours North America for weeks at a time, it receives excited praise from American ballet experts, it has been to eastern Europe and Australia. At the 1968 International Festival of the Dance in Paris it won the gold medal for best company, and its prima ballerina, Christine Hennessy, won the gold medal for best female interpretation.

Spohr and his dancers have maintained and expanded enormously the tradition that

began in the late 1930s. "We have continuously grown, as a good tree grows," Spohr has said. Spohr's particular direction of growth has been towards an unusually masculine style. He has sought out male dancers of great strength and vigor, and wherever the company goes critical words like "vitality" and "virility" follow it. Spohr has also been, in his approach to the subjects of ballets, resolutely Canadian. The Royal Winnipeg's ballets are often on Canadian themes, like *The Ecstasy of Rita Joe*, based on George Ryga's play about an Indian girl. One of its ballets is *The Shining People of Leonard Cohen*, based on the Canadian writer's eloquent poetry. Like Les Grands Ballets Canadiens, the Royal Winnipeg has also worked with rock musi-

cians. Its most celebrated collaboration was *A Ballet High*, a 1970 production with the Toronto rock group Lighthouse that made one of the most brilliant and exciting evenings in the history of Canadian dance.

There is something about all of the company's works that speaks eloquently of its own time and place. "I am not afraid to be Canadian," Spohr has said. "And that is to be responsive to the people, climate and feelings around me every second of my life."

Dance in Canada is not by any means limited to the three major ballet companies. Ethnic groups in various parts of Canada have brought the dances of their European countries to Canada and have added them to the culture of the country. Modern dance too has taken root in Canada. Groups like the Toronto Dance Theatre and Le Groupe de la Nouvelle Aire of Montréal have won sizeable audiences both in their home cities and on tour. Universities often include modern dance in their curricula and in the late 1960s and early 1970s a new generation of dancers began emerging in Canada. Their work was in part inspired by the older companies and in part a reaction to them: modern dance has its own special vigor and its own appeal.

Even in Winnipeg, where the Royal has long been the most sparkling jewel in the cultural crown of the city, modern dance has taken root—partly because the Royal itself is there. Rachel Browne, a dancer originally from Philadelphia, came to Winnipeg in 1957 to join the Royal. She spent five seasons with the company; then she set out to create her own kind of dance. She drew around her a group of pupils equally

interested in exploring new ways, and by 1970 she had a fully professional company, the Contemporary Dancers, which went on tour and appeared on television. Once more an immigrant had provided the spark for a Canadian dance company. Once more the impulse came from a newcomer, the response from native Canadians.

Contemporary Dancers has no set style and no formula. In this sense it is typical of the struggling little companies that in the 1960s began to set out on the difficult, arduous road that had already brought the major ballet companies to eminence. Their early activities made it clear that the story of dance in Canada would continue to be a story of struggle.

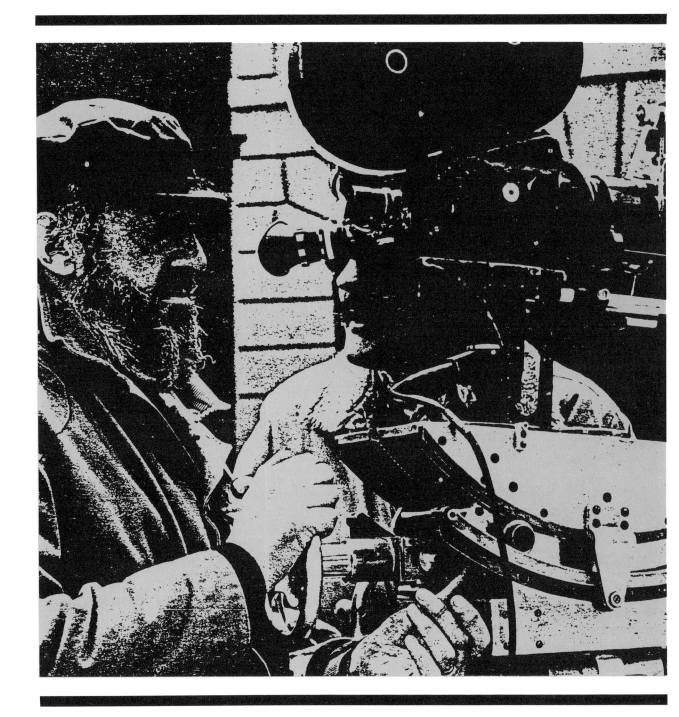

8 Flickering Shadows of Identity

I must deal with what I know and find out what makes it universal.

— Gilles Carle

One evening in September, 1973, the French-language television showed Claude Jutra's *Mon Oncle Antoine*, a movie about small-town life in Québec in the 1940s. This was the most praised film ever produced in Canada, the film of which a New York critic had written that it "must be ranked with world masterpieces." It was the work of a director who had come up through the National Film Board ranks, had done documentaries and films of personal confession, and who now had made a statement about Québec life, about religion, about love and death and bitterness in an unyielding Canadian winter. By now *Mon Oncle Antoine* was already a success in Canadian movie houses, but what happened in September, 1973, indicated just how large a success it really was. According to a survey conducted shortly after, the audience for *Mon Oncle Antoine* in Québec that night was 2 569 000 people — more people than had ever before watched a movie of any kind on French-Canadian television.

That night can go down in history as a kind of climax to the first period of Canadian feature moviemaking. The rare and marvellous thing had happened: an artist ideally suited to his medium had found his perfect audience. *Mon Oncle Antoine* was a moderate success in English Canada too, and it had some excellent reviews in the United States, but that appearance on Radio-Canada was the sort of thing that the Québec filmmakers and their supporters had been working towards for something like fourteen years.

In 1960 there were almost no Canadian movies — not movies in the way most people mean that word. There were documentaries, some of them among the world's best; there were fine industrial films, made for private companies to explain their work; there were some good short films made for television, not only in Montréal and Toronto but also in Vancouver. But there were no feature movies — movies lasting an hour and a half or so, intended to tell a story and provide an evening's entertainment or stimulation. When Canadians went to the movies, they never saw themselves on the screen. They saw Americans, English, French, once in a while people from other countries. But if a Canadian appeared in a movie it was only for a moment or two, and always as seen through the eyes of people in another country. To be in movies, Canadians — from Mary Pickford through Deanna Durbin and Walter Pidgeon to Kate Reid — had to move to other countries.

Very few Canadians considered this a public issue of importance. Movies were things made elsewhere, and most Canadians accepted that

fact. But several factors changed the minds of at least a sizeable and influential minority. First, the National Film Board in Montréal, particularly its French-language section, was turning out streams of expert filmmakers, and naturally the idea of feature movies occurred to some of them. Second, experience in television (which came to Canada in 1952) made Canadian directors and actors think about showing their talents in a more challenging way. Third, and most important, Québec in the early 1960s went through a major change in the way its people thought about themselves. The Québécois became less shy about asserting themselves; their artists began to proclaim the value of Québec identity. And as they looked out at the way people elsewhere expressed themselves, they focused on the cinema.

Claude Jutra was part of this process. He was born in Montréal in 1930; he went to medical school and graduated, but even as a student he was experimenting with movies. By 1956, when he was in his mid-twenties, he was working with the National Film Board, and in 1957 he was the actor in Norman McLaren's *A Chairy Tale*. He worked in France and Africa, made documentaries about Québec life, and quickly established a reputation for originality and vision.

It was in 1963 that he became, in effect, the star of what was then the emerging Québec movie scene. He directed and co-starred in *A tout prendre (Take It All)*, an intensely personal and autobiographical film in which he played himself and explored his identity and his sexuality. For its time, *A tout prendre* was as important as *Mon Oncle Antoine*. It made the point that it was possible for a Québec artist to evolve as a filmmaker and make a personal statement through a movie.

A tout prendre first appeared at the Montréal Film Festival of 1963. As an American critic, Andrew Sarris, later put it: "Jutra was the hero of the hour."

Around that same time there were other signs that the Canadian cinema was coming slowly to life. In 1963 the National Film Board released a feature-length movie, *Pour la suite du monde (Moontrap)*, about some Québécois on an island in the St. Lawrence who trap a white whale according to the traditional and almost forgotten methods of their ancestors. The film was prepared by Pierre Perrault and by the great cinematographer Michel Brault. It was a documentary, like most Film Board products, but it was more ambitious than almost any documentary the Board had ever produced before.

It helped to begin the renaissance in Québec filmmaking—a cineboom, it was once called—which continues to this day. Québec filmmakers in the 1960s and the 1970s began to produce films that showed great energy and ambition. Sometimes they produced highly commercial sex films—"skinflicks"—for both the local and international trade, and often they did very well with these. One of the earliest successes, *Valérie*, directed in 1969 by Denis Heroux, was about a girl who leaves a Québec convent and becomes a prostitute in Montréal and Toronto. It was advertised by one Toronto theatre as a "Canadian-Made Film in Swedish Style", but in fact it reflected in its own crude terms, certain central issues in Québec life—primarily the contradictory pulls of religion and the new permissive lifestyle of North America.

In this, if in no other sense, *Valérie* was typical of the new Québec films. They were all rooted in the life of Québec and in the problems

of Québec consciousness. Some of them might be successful in France but if they were, they succeeded as Québec films, not as imitations of films made elsewhere.

In this the work of Gilles Carle was most typical. His films, like *Red* and *Le viol d'une jeune fille douce* and *La vraie nature de Bernadette*, reflect directly the lives of modern Québec people. His characters are the people of Québec, making the difficult transition from traditional to modern ways, frequently from rural to city ways. His first feature, *La vie heureuse de*

Léopold Z (1965) was a merry comedy about the difficult life of a snowplow driver in Montréal. Later he was to tell us about farmers, workers, criminals, lumberjacks. Always in his films the people speak a very specifically Québec version of French, not to be mistaken for the language of France. Carle thinks the themes in his films may interest people everywhere; he's not interested in pure regionalism. But he wants his work rooted in his own particular culture. "There's nothing more disgusting," he says, "than a film without a culture." Almost everyone who watched Canadian

movies in the 1960s and the 1970s agreed that Carle had never made this mistake. As Martin Knelman said, in the Toronto *Globe and Mail*, Carle was "an authentic voice of the new Québec."

Carle in a sense was typical of the new moviemakers in Québec: dedicated, ambitious, wide-ranging in their choice of subjects and themes, often nationalistic. These filmmakers encountered many difficulties and disappointments and sometimes it seemed they planned far more films than they made. But they were reaching an audience that wanted to hear what they had to say, an audience that for the first time saw its own life reflected on the movie screens.

Things were different in English Canada. About the same time that the National Film Board made *Pour la suite du monde*, it also turned out a feature in English: *The Drylanders* (*Un autre pays*). Directed by Donald Haldane, *The Drylanders* described the life of a rural family in western Canada over a generation. It evoked a strong response in the West but showed to small audiences elsewhere. It indicated, however, that there was material for feature films in Canada, and people who could make them with competence.

In 1964 there were many more signs of life in French Canada and at least one important event in English Canada. Don Owen, a National Film Board staff director, was assigned to make a short about the work of a parole officer in Toronto. Instead he stretched his budget and shot enough film to make a feature, *Nobody Waved Goodbye* (*Départ sans adieux*). It was not successful in Canada, but over the next year it was greeted with enthusiasm by critics in France and the United States. Owen became one more of the growing list of Canadians who had shown themselves capable of making features.

But Canada had come late to the business of moviemaking, and there were serious difficulties ahead. For one thing, movie audiences in Canada – as in all other countries with television – were drastically declining. While movies seemed more and more important to some people, and became the subject of an increasing number of books and college courses, fewer people were actually paying to see them. It was not a happy time to enter the market. There were troubles within the film industry too. Money to back movies was short, there were few Canadian stars who might draw ticket-buyers to the box office, and in some areas – film writing, for instance – few Canadians had been adequately trained.

The federal government, convinced that a movie industry was essential, decided to help create one. The National Film Board had been a government agency since its creation, and various government departments had been involved with documentary films since the 1920s. But now Ottawa decided that a private film industry, bolstered by public capital, was the natural next stage of development. In 1968 the Canadian Film Development Corporation was started; its aims, according to Parliament, were "to foster and promote the development of a feature film industry in Canada" by investing in feature films, lending money to producers, making awards for outstanding accomplishments, and offering both advice and educational grants to filmmakers.

It was generally believed that without this government assistance the feature film industry would never have substantially developed. With

such assistance, an industry did begin to grow – a small one, a faltering one, but still an industry. In the next few years scores of films were produced, some of them successful; hundreds of Canadians were employed as directors, actors, writers and camera technicians. For a young man or woman, the idea of a film career within Canada became a serious possibility.

Don Shebib was typical of those whose careers were beginning to flower in the late 1960s and early 1970s. Born in Toronto in 1938, he studied at the University of Toronto and then en-rolled in a film course at the University of California at Los Angeles. Typically, for a Canadian filmmaker, he learned much of his craft as a documentary maker for the Film Board and the CBC; and, typically again, his later films showed this. It was also typical that to make his first feature film he had to go to extraordinary lengths. Just as Don Owen had to stretch a documentary short into a feature, so Shebib had to beg and borrow his way toward the status of moviemaker. He received a token grant of $19 000 from the Canadian Film Development Corporation, and

he had to accomplish the rest on nerve. When the film was finished he told an interviewer: "It was the worst experience of my life. It was like running a race and not daring to look over my shoulder. All I could do was try to keep one jump ahead, trying to cope . . . " Some of us may imagine that moviemakers lead hectic but essentially secure lives; in fact their careers proceed, usually, in an atmosphere of desperation and hysteria.

But out of that atmosphere there emerged, miraculously, Don Shebib's *Goin' Down the Road* (*En rouland ma boule*), a witty and charming and compassionate movie about two Maritimers who move to Toronto in search of better jobs and find only despair and bitterness. Shebib created, in his two main characters – played by Paul Bradley and Doug McGrath – perfect symbols of one part of Canadian reality: the deprived underside of the country, cut off from the success many Canadians achieve. His picture played to good audiences in theatres, was shown on television, was well reviewed in the United States. Shebib's reputation was made.

His fortune, however, was not made. Shebib continued to live in the same desperate atmosphere in which there is hardly ever any

guarantee that the money will be available to make a movie. Like most Canadian artists, Shebib remained out at the edge of society, always anxiously concerned about money, always on the verge of bankruptcy. His second film, *Rip-Off* (1971) and his third, *Between Friends* (1973) consolidated his reputation and made clearer the themes of his work—the life of outsiders and the relations between men who feel themselves threatened by women. His career continued to be intensely promising and important.

In English Canada there were other directors of importance emerging in that period—Peter Pearson with *Paperback Hero* (1973), William Fruet with *Wedding in White* (1972), to name two important figures—though none of them was as prolific as Québec directors like Carle or Jean-Pierre Lefebvre. Through the 1960s, and well into the 1970s, Québec was the real centre of Canadian filmmaking. The centre within that centre was of course Claude Jutra and today *Mon Oncle Antoine* remains the enduring monument of the pioneer days in Canadian feature films.

Mon Oncle Antoine describes a teenaged boy's maturing realization of how difficult, confused and embittering adult life may be. The boy, Benoît (Jacques Gagnon), lives in a small Québec town with his uncle Antoine (Jean Duceppe). Antoine is both the leading town merchant and the undertaker, but he hates the mean life of the town. He comforts himself with frequent drinks of Bols gin, and with drunken outbursts against his fate. Benoît's aunt, Cecile (Olivette Thibault) is unfaithful to Antoine, sleeping with their store clerk (played by Jutra himself).

What emerges from the film is a rich, dense feeling of the town itself, and of the un-hopeful people who live within it. There are moments of genuine terror (as when the undertaker and young Benoît drop a body off the back of their sleigh on a snow-covered road) and there are moments of great beauty (the landscape is beautiful, and so is the sweetness of young Benoît). There is at times a gritty documentary feel about *Mon Oncle Antoine* but at the same time there is a soaring poetic spirit behind it. Like all great films, it has a largeness of spirit. As Penelope Gilliatt described it in the *New Yorker:*

> **The film's topic is resentment, but its quality is sunny, because of the calibre of its observation, which notices people's moments of hesitation and gaiety with a charmed and singular eye. It is much more expansive than its guilt-ridden subject suggests, and in the last two-thirds it has the generosity of a very purely detailed piece of work.**

For all the people who made or worried about Canadian features in their early years, there was much that was discouraging and embittering. But in their worst moments they could find encouragement and a refreshment of spirit in contemplating *Mon Oncle Antoine.*

In English Canada there was no pattern of success to equal Québec's. English Canada produced a few successful violence films like *Black Christmas* and *The Parasite Murders* but its serious films usually played to small houses; sometimes they were shot and finished and then never shown to the public at all. Only a very few theatre owners were interested in exhibiting English Canadian movies, and this fact led—in the

mid-1970s—to a demand on the part of filmmakers that government force the theatres to show a certain percentage of Canadian films.

The great exception to all of this, in English Canada, was *The Apprenticeship of Duddy Kravitz*. Made in 1973, it was shown in 1974 not only to huge audiences in Canada but to large audiences in the United States as well. Based on the most famous of Mordecai Richler's novels, it was a witty, biting film about the Jewish community in downtown Montréal and especially about one charming rascal, Duddy. The film was directed by Ted Kotcheff, a Canadian who had served his own apprenticeship in CBC television in Toronto and then had worked extensively in England. Kotcheff brought in a group of American stars who fitted perfectly into the Montréal scene: Richard Dreyfuss, as Duddy, gave a spectacularly brilliant performance. The film showed an attention to detail and a sense of period that movies elsewhere had often attained but movies in English Canada had rarely even attempted. It set a new standard and created new hope for English Canadian movies.

The National Film Board will be the eyes of Canada. It will, through a national use of cinema, see Canada and see it whole.

The man who said that was the most important figure in Canadian films in the years before the 1960s. He was John Grierson, a Scotsman of great talent and vision. Today his name is known everywhere in the world where documentary films are discussed, but in the 1930s he was most famous as the director of the General Post Office Film Unit in England—a group of filmmakers who created many original and beautiful short films. In 1939 he was brought to Ottawa by the federal government to suggest how Canada might use films in the national interest. As on so many other occasions, this federal action was to prove a turning point in the cultural life of the country. Grierson submitted a plan for a new government film agency, and when the National Film Board was established Grierson was made its first film commissioner and chairman of the board. He was to stay in Canada until 1945, and to leave a permanent imprint on Canadian films.

Soon after Grierson started work, the Second World War began and it quickly became clear that Canadian films were needed most in

the war effort. During the war the National Film Board became a vital link among Canadians, and a major federal institution. In those years before television a war seemed remote and almost unreal to most people. And yet it was essential to enlist Canadian support – the war was, in fact, the greatest single industrial project on which Canada had ever embarked. Ottawa realized that it was necessary to *show* Canadians what they and their allies were doing.

For this purpose the Board developed two long series of short films, *Canada Carries On* and *World in Action*. The first dealt with how Canada was fighting the war, overseas and at home. The second dealt with the global strategy of the war and Canada's role in it. Both series were amazingly effective: they were, in fact, probably the most important propaganda tools ever created in Canada. Under Grierson's leadership the filmmakers in Ottawa – some of them imported from Britain, some developed by Grierson in Canada – quickly rose to world standards. In 1941 a *Canada Carries On* short won the first Academy Award ever given to a Canadian film.

The National Film Board was then beginning a kind of missionary approach to films – the same approach it carries on today with its *Challenge for Change* series, in which various communities express their problems through film and videotape. In the early 1940s Film Board shorts were shown in the movie theatres of the cities and towns, but there were still many Canadians in rural areas who had no access to them because their communities had no theatres. The Film Board created the job of "itinerant projectionist". The projectionist went out equipped with a projector, a screen and even a portable power

generator; each month he was given a new program of films. By 1942 there were thirty rural circuits established, each with twenty or so screening points. Later, the itinerant projectionists went to factories and union halls, and the Board's films also were spread through schools and libraries and service clubs.

The films shown in these humble circumstances were creating a Canadian style of moviemaking, based partly on Grierson's own background and partly on the specific needs of the country in wartime. The National Film Board people concentrated on the ordinary aspects of life in wartime; their approach avoided glamour and sought to present the people on the screen as essentially similar to the people in the audience. Hundreds of filmmakers were trained in this way, and their effect was felt for decades after – not only at the Film Board but in television and in feature films. To this day there is still a documentary feel to many feature movies in Canada. The standards Grierson established were eventually recognized around the world, and the hundreds of Film Board features have together won more than 1 100 international awards.

When Grierson left Canada in 1945 – he was to return often for visits and lectures until his death in 1972 – he said this about his work: "We have . . . sought to find themes which gave a new significance to the terms of ordinary living. Sometimes we have approached the task on a journalistic level or a poetic level or analytical level or more dramatic level, but always we have been concerned to bridge a gap between the citizen and the world about him and always we have been concerned to find a degree of beauty in the process and make our own contribution to the

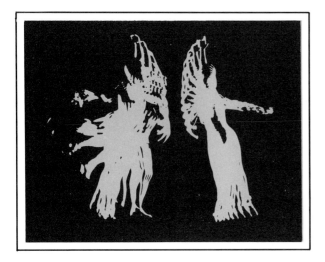

spectacle of democracy at work." At that moment he had behind him an accomplishment unique in the history of Canadian culture. As executive, artist, craftsman and journalist, he had brought together the best of the country's artistic resources and used them for a creative social purpose. Few other Canadians in the arts, before or since, have been able to do so much.

When Grierson returned to Britain, many of those who had come with him also returned. One who did not was Norman McLaren, and if he was exceptional in this way he was also exceptional in most other ways. While his contemporaries at the Film Board laboured toward the presentation of ordinary life, McLaren worked equally hard at the creation of the extraordinary.

He was born in Stirling, Scotland in 1914, to a family of house painters and interior decorators. He went to the Glasgow School of Art in the early 1920s to study interior design, but during his years there he became fascinated by the possibilities of film. McLaren and motion pictures were, apparently, made for each other. "I had started dreaming of pictures that sort of have movements in them, moving forms and so on," he said in later years. "I listened to music a lot of the time, and forms suggested themselves in motion to me . . . " From the beginning he was involved in the very form of art that would make him famous. While he was still at school he acquired the worn-out print of a commercial film from the local theatre, carefully scrubbed the images from it, and then painted moving pictures on it with brush and coloured inks. He wasn't the first person to do that—an Australian had done it earlier—but he was to make that art form his own and stamp it with his style.

From the beginning he was conscious that animation *was* an art form, not just a poor cousin of ordinary films. "The animated movie isn't a substitute for a live movie," he has said. "It's something entirely apart that opens a new world of the imagination."

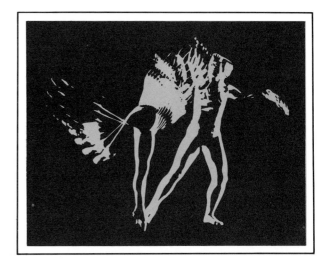

John Grierson discovered McLaren's work in an amateur film contest in 1936. He invited McLaren to join the General Post Office Film Unit, and there McLaren began to perfect his craft. He later worked briefly in New York, where for the first time he created sound on film not by the standard recording techniques but by drawing directly on the sound-track with a pen. He wasn't the first to do that, either, but again he was to become the best-known and most sophisticated artist using that revolutionary technique. In 1941 Grierson summoned McLaren again, this time to the National Film Board of Canada. There—from the 1940s to the 1970s—he was to do almost all his most important work.

In the beginning he was, like most Film Board artists, a wartime propagandist: in the early 1940s his films had to do with subjects like buying war savings bonds and fighting inflation. But with the war's end he resumed his experiments in earnest, and—backed by the increasingly proud and fascinated executives at the Board—he became one of the few Canadian artists of the period whose names were known around the world.

Sometimes McLaren drew directly on films; sometimes he took still photographs or cinematic films and then manipulated them to his purpose. He grew most famous in the beginning for "cameraless films" like *Fiddle-De-Dee* (1947) but later he expanded into the use of real actors, as in *A Chairy Tale* (1957). There was often a social message in his films—*A Chairy Tale* is really an allegory about the need for each individual in the world to respect the feelings of others. Sometimes the messages were more blunt: in *Neighbours* (1952), which won an Academy Award, McLaren shows us two men who begin with a quarrel over a flower on their mutual property line and end by destroying each other. The message, love your neighbour, is spelled out in many languages at the end of the film.

But McLaren, given nearly complete freedom by the Board, felt capable of making films whose messages were less direct. *A Phantasy* (1952) was a surrealistic film, of which he said: "Some of the things, images, and movements that turned out sort of surprised me. I don't know what they meant in terms of the pictures as a whole, or in terms of their absolute meaning . . . It's quite possible for people to take many different meanings." At times McLaren was operating as an abstract artist in the world of cinema. In later years he turned to increasingly lovely and haunting images, as in *Pas de Deux* (1967), a ballet film that has been one of the most praised films ever made by a Canadian: at various film festivals around the world it won about two dozen awards. In *Pas de Deux* McLaren printed the film's negatives in multiple images, so that on the screen you see at once the movement that has just taken place, the movement that is now taking place, and the movement *about* to take place. Like all of McLaren's work it is both innovative and deeply personal.

McLaren has learned from other filmmakers, and he has taught others—sometimes through his films, sometimes through long teaching visits to places like India and China. But there is no "McLaren school". He stands alone, a unique figure in world cinema and a unique figure in the culture of his own country—the only Canadian film artist whose work has consistently reached beyond Canadian borders and made itself felt everywhere that movies matter.

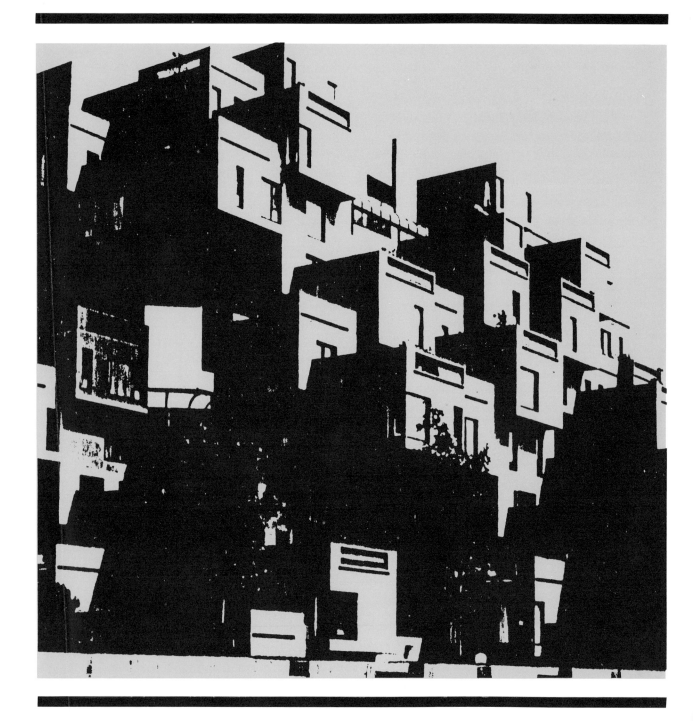

9 The Soaring Cities

There is little doubt that we are in the midst of a revolution of a much more profound and fundamental nature than the social and political revolutions of the last half century — a revolution so subtle and yet so encompassing that we will only gradually be aware that everything has changed — completely changed — and that nothing is as it was before.

— Arthur Erickson

Architecture as you encounter it across Canada in the 1970s is an art constantly changing, just as society is constantly changing. Architecture is more closely tied to society than any other art form.

Poets or painters can follow their own private visions and produce work that only they and perhaps a few others appreciate, but architects cannot do that. They must reflect the desires, moods, and hopes of their fellow citizens. They must especially reflect the decisions of society's leaders, because architecture is the only art in which all the final decisions are made by non-artists: business and government officials give the final approval to the architect's art. They let it happen.

If you want to know a country's real nature, then, study its architecture. Canada has no great architectural tradition, but it has a history of distinctive building. The French settlers along the shores of the St. Lawrence in the seventeenth century brought with them the traditions of provincial France and you can still see some of the churches and houses they built as they imported their old culture and developed a new one. High Victorian design from England played a major role in Canadian building in the late nineteenth and early twentieth centuries, and in many cities you can see government buildings and universities that were built in that tradition. Today such buildings are cherished relics of the past, passionately protected by citizens' groups intent on preserving them.

But architecture in our own time came alive only when Canadians began to think and argue seriously about the nature of their cities. In the years since the beginning of the Second World War, Canada has changed from a rural to an urban society. Many thousands of Canadians have left the countryside for the cities, and a majority of the immigrants who have arrived since 1945 have been drawn to the cities in search of jobs.

All of this has been reflected in the ar-

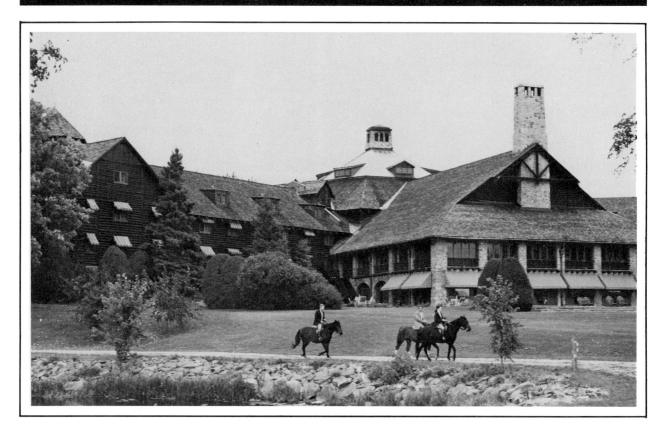

chitecture of our time. Canadian business officials have created dozens of office towers and hundreds of apartment buildings in and around the cities. In the 1950s, during the first great wave of post-war construction, these buildings—in Montréal, Toronto, Vancouver—tended to be planned without great care. They were simply placed in rows along already existing streets.

But in the late 1950s and the early 1960s Canadians began to develop a more thoughtful attitude toward their cities. They demanded better planning. People began to think of cities not just as collections of buildings but as communities where citizens gather to enjoy themselves and express themselves rather than just work. Canadians began to see the virtues of the great old European squares, where the physical design encourages people to mingle and stroll. It became clear that many of the new buildings were too crowded together; more space was needed, and more imagination.

The special needs of Canadian cities began to attract attention from architects and planners. If Europe had its open squares, what would be equivalent for Canada? In many parts of the country the winter lasts for as much as six

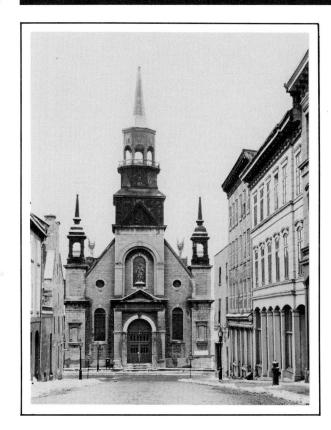

offices and stores without going outdoors at all. In later years Place Victoria and Place Bonaventure were built in Montréal, and the Toronto-Dominion Centre and the Commerce Court in Toronto. Most of them had outdoor squares for use in good weather, but the main idea was the "underground city". For millions of Canadians this was among the most important architectural developments of recent years.

Meanwhile, in the suburbs, other architects were responding in a similar way to the Canadian climate. Closed-in shopping plazas, with their climates controlled, began to crop up around the country. One of the most successful and the biggest, was Yorkdale, in suburban Toronto, with scores of shops, theatres and restaurants under one roof. The same idea was carried into a downtown centre with Midtown Plaza in Saskatoon, where an office tower, a community theatre, a convention centre and many shops were gathered together in one structure.

The architecture had an effect on the style of life. Sometimes families would go to the shopping centres for most of a day—to shop, to lunch at a restaurant, to see a movie. Young people made the shopping centres their meeting places, and often family events like wedding receptions took place in rented rooms at the shopping centres. Sometimes the country's leading artists were commissioned to provide paintings and sculpture for the shopping centres.

In many places the shopping centre became the community centre. From this you could also learn something about Canadian society. To an important extent it was focused on buying and selling—the shops were the centre of activity.

All of these buildings, from Place Ville

months. Why, then, couldn't the city centres—or parts of them—be protected from the snow and the cold? Why couldn't people stroll in comfort from place to place?

Place Ville Marie, in downtown Montréal, was the historical beginning of an architectural trend that began in the early 1960s and hasn't stopped yet. It combined office buildings with shops and theatres in an underground location. It became a model for later centres. In Montréal and Toronto some of these centres were linked with the subway systems, so that workers and shoppers could go directly from the subway to

Marie to the smallest indoor shopping centre, represented the creation of what might be called an urban consciousness. People were coming to see that cities could be convenient and comfortable—and perhaps might even be works of art, as they so often were in Europe. While trying to preserve the best of the old buildings they were also intent on creating new urban spaces that would be comfortable and perhaps handsome as well.

Place Ville Marie was a kind of turning point for Montréal. In Toronto a similar turning point was reached when the city council decided to hold a world-wide competition for its new city hall. Architects from all over the world submitted designs—there were 520 entries, from forty-two countries—and the winner was Viljo Revell of Finland.

Revell was a name entirely unknown in Canada when the competition's result was announced, but he turned out to be an architect who would leave a deep impression on one important part of Canada. His city hall was a building such as no one had seen in Toronto before—and few had seen anywhere. A Toronto architect, Irving Grossman, described it as "a bold example of architecture as pure sculpture. Seen from certain parts of the city, it rises above the skyline as two vast, curved concrete walls, of heroic scale and simplicity, reminiscent of historic monuments of the past. On closer look, one recognizes these as two office towers which embrace a low mushroom-shaped council chamber, and overlook a vast plaza destined for public ceremonies and community festivals."

Revell's building achieved two great purposes of architecture. First, it summed up the people's view of themselves. Toronto people looked on it with great pride and satisfaction. When they saw it they realized that Toronto had the possibility of becoming a great modern city. If Toronto could have a building as adventurous and impressive as this, then the city as a whole could be adventurous. Partly as a result, the people of the city came to have a new interest in their own community, and a new pride in it.

Second, Revell's building became a kind of focal point for the city. People crowded into the city square in all weather—in the summer to hear speeches or rock bands or just stroll; in the winter to ice skate on the rink at the south end of the great square. Partly because of the building, Toronto people felt drawn closer to city politics and a new era of reform government was born.

Across Canada in the 1960s a new consciousness of the arts arose, along with new urban consciousness. Public spaces for music, theatre and dance became essential aspects of Canadian city life. The Montréal architects Affleck, Désbarats, Dimakopoulos, Lebensold and Sise were major figures in this movement, designing the Montréal Place des Arts, the Confederation Centre in Charlottetown, the National Arts Centre in Ottawa. Raymond Moriyama became a leading figure in the Toronto area with his Ontario Science Centre and his Japanese Canadian Cultural Centre. Canadians, as never before, demanded public places for art and recreation, and looked to the architects to provide appropriate designs. More often than not, the architects were able to provide inspired designs.

These public buildings suggested what good architecture could accomplish for the future of Canadian cities. But they were not the begin-

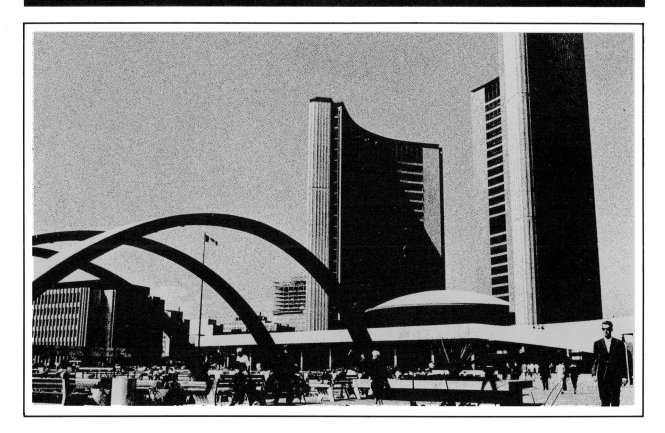

ning of modern architecture in Canada. For years our architects had been adopting and developing the new styles from Europe and the United States – and developing some of their own. In Toronto the austere and perfectly proportioned buildings of John C. Parkin had been winning attention since the 1950s. Earlier still, modern architects in Canada had made their first strong impression not with public buildings but with private houses, and not in the eastern cities but in Vancouver.

There, in the early 1950s, a kind of modern movement took hold. It produced dozens of beautifully designed private houses, many of them featuring the creative use of wood. During that period it seemed to many people that all the best architecture in Canada was in B.C. Arthur Erickson has written about those years:

> In 1956 it was the Vancouver "school" that caught the admiration of the country. Unfettered by the constraints of climate, the Vancouver school was able to show a freedom in planning and a bold use of materials that was impossible in eastern Canada.

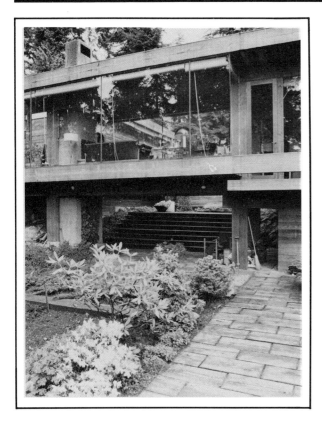

The mild climate was a crucial factor—wood and glass could be used freely. But, as Erickson went on, there was also the inspiration of the matchless B.C. landscape:

> **It was ... the natural surroundings that evoked a poetic response from a few architects. For them, the house was more of a device to enhance the magic site—to take advantage of the shifting moods of light and the great diversity of view, to lead one through an experience of nature as if the house were landscape itself.**

The B.C. architects in those years developed an approach that was unique in Canada. Their work was humane, close to nature, and very personal. Two men of that generation spread their influence far beyond British Columbia. One was Arthur Erickson. The other was Ron Thom.

It is significant that both of them are most widely known for building universities—Erickson and his partner Geoff Massey built Simon Fraser University at Burnaby, B.C.; Thom built Trent University at Peterborough, Ontario, and Massey College in Toronto. Their work was part of the university building boom in the 1960s.

In that period another fundamental change occurred in Canadian society. In the past, education beyond high school had been limited to a small proportion of the citizens. But in the early 1960s it became clear that a modern society would require much larger numbers of well trained people. Canadians demanded far more university and college education, and provincial governments hastened to provide it. Everywhere universities expanded and new universities were created; community colleges were provided by the dozens.

In many cases the architecture was ordinary, but in a few cases it was distinguished. One such was Simon Fraser, an entirely new university designed by Erickson. It is now a leading tourist attraction in the Vancouver area; certainly in the mid-1960s, when it was built, it was the most talked-about new building in western Canada and perhaps the most admired of all the buildings created by the new generation of architects.

Erickson is among the outstanding figures

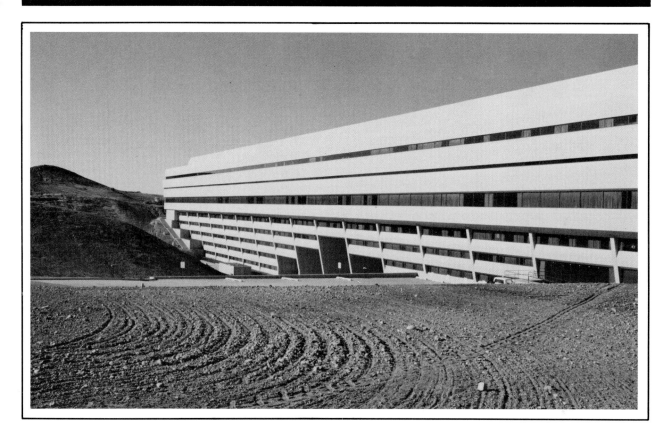

in Canadian architecture and he has has held that position since about 1965. Geoffrey James wrote of him in *Time* magazine in 1972: "In an age of team design, Erickson epitomizes the idea of the individual creator, the architect as superstar." When he won the competition for the design of Simon Fraser, he brought to the job a wide and rich background.

He had been a painter (good enough to exhibit at the Vancouver Art Gallery at the age of sixteen), a designer of distinguished houses, a teacher at the University of British Columbia, a world traveller, and a serious, careful student of

architectural history. He was, and is, an advocate of good city design. In 1971, when the Royal Bank of Canada gave him the $50 000 prize it awards annually to a distinguished Canadian, Erickson began his speech of acceptance by saying: "I've chosen to speak on the most pressing subject of all—the most maligned, misunderstood, misrepresented of subjects and the most vital to human survival—the city." He then went on to present a passionate demand for more serious consideration of city building by business officials and politicans.

Simon Fraser University is on the top of a

students and teachers a sense of community. He believed he could best provide this by carefully planning the spaces in between the university functions, the walking and strolling spaces, and the interior courtyard where students might meet.

As he wrote later:

> We consider that walking, in the palaestras of classical Greece, the gardens of Buddhist temples, or the cloisters of Christian monasteries, provided both aesthetic pleasure and intellectual stimulation.
>
> The walking sequence through Simon Fraser, from arrival to class-rooms, was planned to be an uplifting one, the architecture unfolding with one's progression, providing spaces for the activities that are necessary for the full enjoyment of campus life. You come out of the lower transpor-tation level and you climb up terraces past classrooms and laboratories and into the roofed-in mall, and you get glimpses of the vistas you can see from the mountain. Then you climb higher, to the summit, to the upper quadrangle, and you see the whole world around, with the realization it has wide, limitless horizons. Educa-tion is like that. As you learn more, you are able to see more of the vistas of human knowledge and experience.

mountain — it stretches along the spine of Bur-naby Mountain and looks down on the city of Vancouver. This is the most important aspect of it and Erickson's first job was to fit it to the site. As it stands now the university blends into the moun-tain as if it had grown there. But the fact that it is so high up also serves as a kind of symbol. As one professor said of it: "This is a living metaphor for me. It is a case of my climbing up to my ideals every morning." Erickson planned it just that way.

Erickson wanted to redefine the university in contemporary terms, to make it meaningful to the people who used it and a natural part of the place where it was to sit. He wanted to give the

Arthur Erickson has done many other buil-ings of distinction — the MacMillan Bloedel head-quarters in downtown Vancouver, the University of Lethbridge, the Canadian pavilion at Expo '70

in Osaka are among them — but his monument, for the moment, remains Simon Fraser. Architects and tourists alike go out to Burnaby to see it and a British architectural journal says it is "mandatory on any North American architectural pilgrimage". The architectural critic of the New York *Times* has summed it up: "Simon Fraser works perfectly as an environment and a monumental piece of architecture."

Ron Thom, like Erickson, emerged from the Vancouver generation of the 1950s. His Trent University, near Peterborough, is one of the most successful of the new universities in Canada. It straddles the Otonabee River in a graceful and intimate yet vigorously modern style. The people who planned Trent University called for a style of building that would fit the university's own style: human in scale, directed to the needs of the individual student. Thom, who had previously designed the quiet and relaxed Massey College building at the University of Toronto, was equal to the challenge. Trent, as he built it, fits comfortably into its rural setting.

Carol Moore Ede, in her book, *Canadian Architecture 1960-70*, writes of Trent:

> **Ron Thom has a feeling for land and form. His awareness that human beings need both public and private spaces is seen in the tremendous open vistas, unexpected closed corners and intimate courtyards. Buildings flow in terraces to the water's edge, making the river a vital nerve centre which runs up the spine of the complex. Land and architecture have become one in the masterly understanding of scale.**

Erickson and Thom are not the only architects who have designed widely admired university buildings. John Andrews, the Australian-born architect, has won a high degree of international fame for Scarborough College, in the eastern suburb of Toronto. Its hillside design and its high, handsome corridors make it one of the momuments of recent architectural accomplishment in Canada.

It is no accident that when you think of the distinguished buildings of the 1960s, you think almost immediately of universities like Simon Fraser, Trent and Scarborough. In the 1960s Canada placed the highest possible emphasis on education, and poured a large part of its energy into providing good education for young people. Our everyday life was dominated by office towers and shopping centres, but when we thought about our highest ideals we thought about universities. In a sense, the new universities summed up Canadians' belief in their future — a belief that became almost religious in quality during those years. Canadians built no cathedrals in the 1960s. They built universities instead.

But religious buildings, which traditionally have drawn on the highest talents of architects, still play a role in modern Canadian building. After the Second World War religious institutions expanded as the population expanded and architects, assigned to produce new church buildings and synagogues, responded by adapting modern architectural forms to religious needs.

One such architect was Douglas Cardinal. He was born in Red Deer, Alberta, the son of a game warden and the great-grandson of a Stony Indian woman. He studied architecture at the University of Texas and absorbed the lessons of

modern design. When he began to create buildings on the prairies — he first practised in Red Deer, then moved to Edmonton — he tried to bring together modern architecture and the needs of the prairie setting.

One of his great successes in this way is St. Mary's Roman Catholic Church in his home town of Red Deer. It spells out in brick and concrete Cardinal's own view of the architect's role:

> **Architecture to me is being concerned not with a preconceived idea of beauty but with an organism evolving out of the needs it serves. A building should wrap around its function like a sea-shell around a sea-urchin, and the shape, texture, form, and colour should be chosen not for unrelated aesthetic reasons but to fulfill the physiological and psychological needs of the client.**

In this case the client was a church but in a sense it was also a community, and that community's physical surroundings had to be taken into account. For St. Mary's, Cardinal designed a building which would fill all the needs of the church — the baptismal area, for instance, would be separated, according to tradition, from the inner sanctuary, and the whole building would be focused on the altar. But at the same time Cardinal made a building that in design and texture seemed to grow out of the landscape. It sits low and snug on the prairie, and its natural brick walls seem to echo the colours of the prairie sunset.

Cardinal did not follow in every detail the usual outlines of the traditional church: he re-

versed the normal style and put the altar — a massive six-ton piece of Manitoba Tyndall limestone — at the centre of the congregation rather than at one end. He put above it a skylight that pours natural light onto the altar. As one architectural critic has written: "This results in an experience which is truly profound. The mood is one of participation rather than polarity." In the 1960s Roman Catholic liturgy turned more and more towards participation (rather than observation) by the congregation, and Cardinal's Red Deer church was a part of this movement. It was also one of the loveliest products of the new Canadian architecture.

The greatest single architectural event in Canadian history was Expo '67, the world's fair at Montréal in our centennial year. Expo drew architects from all over the world to design the national pavilions, and Canadian architects were given opportunities they had never had before. Fifty million visitors came, and for six months walked in a fairyland of architectural shapes: the great domed bubble of the United States, the huge, stadium-sized, glass-walled Russian pavilion, the German pavilion shaped like a tent outside and a cathedral inside.

Expo opened the eyes of Canadians and their visitors to the possibilities of architecture. For the most part, Canadian architecture of modern times had been dominated by box-like buildings; most of these tended to look like one another. Expo, by contrast, showed that architecture could be startling, charming, and playful. Dr. Karl Schwanzer, of Vienna, who designed the Austrian pavilion, said Expo was "the most exciting collection of buildings I have ever seen". Ordi-

nary visitors agreed. When several thousand were asked what they most liked at the fair, the largest group said they liked the architecture.

James Acland of the University of Toronto school of architecture described Expo in these poetic terms: "At long last something of the virility and sensuous delight which have been appearing here and there in Canadian architecture [flowers] in the prismatic structures of this fair. Though montonous cubes towering into our skies have threatened to destroy every vestige of amenity and delight in our cities, the wave of protest against them has now bred a moving exultation of form and structure . . . " The newcomer to Canada can still see parts of Expo on the old site.

Expo didn't change Canadian architecture immediately, and didn't deeply affect the cities we continued to build and rebuild in the 1970s. But it did produce a challenge to Canadian architecture—and to builders of housing all over the world. That challenge was embodied in the personality of one young man: Moshe Safdie, an Israeli-born immigrant to Canada. He designed Habitat '67.

A few years before Expo was planned, Safdie was a student in the architectural school at McGill University. There he was attracted to new theories of design. According to these theories, cheap and good housing could be provided if architecture and building were reorganized on an industrial basis. Safdie began to imagine a world in which apartment buildings and other housing could be built in a mass-produced way, like toasters or radios. Housing, he knew, is one of the great needs of mankind in this period, and he felt that the role of the architect is to provide it in new and imaginative ways.

Safdie brought his ideas to the people who were planning Expo. He argued that a world's fair should be a catalyst for new ideas, a once-in-a-lifetime chance to try great innovations in practical terms. He proposed a unique kind of apartment development: a series of boxes, uniformly built by mass-production process, stacked together in an ingenious way. Each apartment would have its own garden, each would have a great deal of privacy. At the beginning Safdie wanted 1 000 apartments, along with shops and a school. In the end the project was scaled down to 158 apartments, no shops, no school.

Still, it was impressive. It was industrialization carried into housing. An American architectural critic called it possibly the first real victory of the modern industrial revolution.

Safdie became one of the heroes of the world's fair—Habitat brought him building assignments in Puerto Rico, Israel, and several American cities. He became a world-famous theorist of housing and published his views in two important books. As the years passed, he came to recognize some of the flaws in his original theories—he discovered that it was not as easy as he had hoped it would be to bring down costs. Nevertheless, he and Habitat (which is still in use) had made everyone look in a new way at the problems of building places to live. "Housing design," wrote one architectural critic, "will never be quite the same."

10 The Restless Air

A unique Canadian system of broadcasting endures. It reflects values different from those prevailing in the British or American systems. It not only mirrors Canadian experience, but helps define it.
— *Frank W. Peers*

Television and radio frequently cause public argument in Canada. Every year there are controversies over broadcasting: Who should own it? What should it broadcast? Is the quality high enough? These arguments reflect the fact that Canadians care deeply about broadcasting. They care because broadcasting is essential to the country. Someone once said that broadcasting was invented for Canada, or Canada for broadcasting. So many parts of the country are isolated, and even the big cities are spaced so far apart, that only electronic communication can bring them together.

The late Andrew Allan was one of the great figures of Canadian radio. From Toronto, in the 1940s he produced the *Stage* series of one-hour plays which became a kind of national theatre for English-speaking Canada. He told a story once about the effect of broadcasting on individuals, and how this affected his own life as an artist.

He had been producing the *Stage* series for several years and had grown discouraged. There were difficulties with executives at the Canadian Broadcasting Corporation, and he felt his problems were too much to deal with. He had decided to resign rather than produce another season of plays. He was on his summer holidays, and during a train journey to Vancouver he composed a letter of resignation.

As his train headed west from Calgary he met a young girl in the club car. She recognized him from his photographs in the newspapers.

"You're Andrew Allan, aren't you?" she said. He said he was. "You're the reason I'm here." He asked why and she told him.

"We live on a farm, away up north of Edmonton. We're just plain people, I guess. We haven't got any books to speak of, or pictures, or music, or anything. But I have a little radio in my room. Every Sunday night I go up there to listen to your plays. All week I wait for that time. It's wonderful. It's a whole new world for me. I began to read books because of your plays—all kinds of books I never thought I'd be interested in. And now I'm on my way to Vancouver to stay with my aunt—and in the fall I'm starting at the university. And it's all because of you and your plays. What do you think of that?"

As Andrew Allan said when he told the story years later, "What I thought of it was too

deep to be said." But what he did was go back to his compartment and tear up his letter of resignation. There were seven more seasons of Allan's *Stage* series after that, and they were years of glory for Allan and his writers and actors.

The story of the girl on the train sums up some of the important goals of Canadian broadcasting. The girl's home had been linked, by radio, with the rest of Canada. The CBC had managed to bring great literature into her farm home in a vivid and compelling way. Broadcasting had opened up the possibilities of her life.

These are not small accomplishments, yet Canadian broadcasting down through the years has made them possible in thousands of ways. It has never been easy, and it is not easy yet, but it is a crucial aspect of Canadian life.

In Canada, broadcasting is seen as an instrument of national purpose. This is what sets Canadian broadcasting apart from the broadcasting system of the United States. In the United States, television and radio are seen mainly as ways to sell goods; their results are judged on commercial terms. In Canada, Parliament has —over about four decades—consistently expressed the view that broadcasting should serve the Canadian people as a whole and should assist in the development of the nation. It also, of course, sells products.

Canadians often compare their broadcasting system to the railroad. In the nineteenth century, construction of the Canadian Pacific Railway united the country for the first time, making it possible to move goods and people across Canada with comparative ease. That was the key event in the first two decades of Canadian nationhood.

In the twentieth century—we often say —the broadcasting system performs a similar function. It makes it possible for Canadians to share information, ideas, sports and entertainment.

But Canada does not have a strictly *state* broadcasting system, like some European countries. It has a *mixed* system of publicly owned and privately owned stations. The Canadian Broadcasting Corporation, an independent agency owned by the public and given its funds by Parliament, has television and radio networks in both English and French; it also owns television and radio stations. There are also private stations and networks, owned by private corporations or individuals. In addition, Canada has cable-television systems, most of them privately owned. The main purpose of these systems is to bring good television service, both American and Canadian, to

private homes—often to homes where reception of TV signals is otherwise poor. But these systems also produce a great many local programs for their communities.

In this way, the Canadian broadcasting system expresses the nature of Canada. Canada is not a socialist country, yet it has certain institutions like those of the socialist countries. It is not strictly a capitalist country, yet it has many of the qualities of a capitalist country.

Return, for a moment, to Andrew Allan and the *Stage* series. When it went on the air, not long after the Second World War, there was (as we have seen in Chapter Five) no really substantial theatre in the country. Certainly there was nothing that could be called a national theatre. Allan and his colleagues used radio to play the part that live theatre has played in some other countries. He created a stock company of actors who appeared frequently. They included John Drainie, Christopher Plummer, Frances Hyland, Budd Knapp, Lorne Greene and Barry Morse. He also created a body of writers who supplied original scripts for the program. Among them were Lister Sinclair, W.O. Mitchell, Harry J. Boyle and Joseph Schull.

The *Stage* company produced scores of new plays dealing with everything from the life of Canada's first prime minister to the age of Christopher Columbus. It did the classics too—one season it performed the eight chronicle plays of Shakespeare. For many Canadians the *Stage* provided the first chance to experience the classics and to know what Canadian writers were doing. At the beginning the program reached only a small audience; it was considered highbrow. Later the audience grew, so that at one time it was said to be second only to the audience for hockey broadcasts.

Later, as Canadian culture grew broader and more opportunities opened up for actors and writers and directors, the CBC in this respect became slightly less important—eventually it was not the *only* source of dramatic entertainment. But as television appeared and became the dominant medium, Canadians still looked to the CBC for a uniquely Canadian expression.

Providing a means for this expression, in the face of monumental competition, has been the most serious task of our broadcasters. Through the history of Canadian broadcasting one theme remains constant: the struggle to keep Canadian broadcasting Canadian, the battle to prevent our airwaves from being overwhelmed by American programs. This has been slightly less important in French Canada, where the language

provides a kind of barrier and forces French Canadians to produce their own programs. But in the Canadian system as a whole, both French and English, independence has been a key issue.

The struggle goes back to the 1920s, when radio broadcasting to private homes became a part of modern life. In those early days there were many Canadian stations but they were weak and unorganized and they served only the large centres of population. Well into the 1920s as many as half of the citizens were out of reach of Canadian stations. And there were few Canadian programs: many of our stations found it easier and cheaper to play American recorded music and import American programs.

In 1928 the federal government appointed a royal commission to investigate the situation. Sir John Aird, president of the Canadian Bank of Commerce, was the chairman. The commissioners held hearings in Canada and visited broadcasters in the United States and several European countries. In New York they went to the National Broadcasting Company and were told there that NBC was planning to expand its system to cover the whole of North America. The people at NBC assured them confidently that Canada would get the same quality of service as the United States. NBC assumed, as perhaps some other American broadcasters assumed, that Canada was naturally a part of their market.

Aird and the others decided this was not good enough. As they said in their report, they had discovered among Canadians "unanimity on one fundamental question – Canadian radio listeners want Canadian broadcasting." There was no immediate action, partly because some leading Canadians were opposed to control by the government. Private broadcasters, for instance, understandably expressed the view that broadcasting could best be done by private companies. There were also Canadians, particularly in Québec, who felt broadcasting should be controlled by the provinces.

But in 1932 the federal government acted: it established the Canadian Radio Broadcasting Commission. This historic step, in its way as important as the decision to build the CPR, led eventually to the creation of networks in English and French combining public and private stations. In 1936 the CRBC was replaced by the Canadian Broadcasting Corporation, which continues to this day.

In the Second World War, radio was a key element. Canadians were deeply involved in the war, but they were separated from the fighting by the Atlantic and Pacific oceans. Radio provided us with a means of obtaining quick information and – equally important – a sense of involvement. There were scores of documentaries on the war in English and French, and many dramatized and fictionalized accounts of Canadians at war. Americans and Britons could see their warriors in action at the movies; Canadians, having no movie industry, relied on radio. Drama serials like *La Fiancée du Commando* and *L for Lanky* (about Canadians flying a Lancaster bomber) made the war real for those at home.

The war brought with it a change in Canadian social thinking. Throughout the war Canadians stressed that a new society would be built when the war ended – a society of greater opportunity for the mass of citizens. CBC radio reflected this: in the war years it developed citizen participation programs for farmers and others; it

created school broadcasts and radio colleges.

Television came to Canada in 1952. CBFT Montréal was opened on September 6 and CBLT Toronto two days later. But many Canadians were already watching television: they had purchased sets and were viewing American stations from border cities like Bellingham, Washington (near Vancouver), and Buffalo, New York (near Toronto). In the beginning the first two Canadian stations broadcast only eighteen hours a week – Toronto entirely in English, Montréal in both French and English. They reached between them only thirty per cent of the Canadian population.

Canadian television grew swiftly. The next year an Ottawa station was added, the various stations were linked by a microwave network, and soon private stations began going on the air,

all of them linked to the CBC. Late in 1953 CBUT Vancouver went on. By the end of 1953 CBC television was available to more than sixty per cent of the population.

In the first year the CBC was linked to American networks and CBC viewers could see American programs live. But from the beginning there was an earnest effort to produce Canadian programs, and for a time these dominated the schedule, in English Canada as well as French Canada.

Dramas, variety shows, public affairs discussions, serious music programs: Toronto and Montréal began producing them by the hundreds. Sometimes programs appeared on both French and English networks. *La Famille Plouffe*, one of the earliest téléromans from Radio-Canada, became *The Plouffes* on the English network and viewers across the country saw Roger Lemelin's intimate and comic view of French-Canadian family life, with great Québec stars like Denise Pelletier and Jean-Louis Roux. *L'Heure du concert* from Montréal, a program of serious music and ballet, was seen on both networks in its original version.

In French Canada, television created a whole generation of writers and actors and variety stars. The serials on Radio-Canada dealt with Québec life of the moment and made a tremendous impact, creating stars of a kind English Canada has never known. Radio-Canada also created a significant figure of another kind: René Lévesque, who was to become one of the leading politicians in Québec in the 1960s, began his public career as a commentator on Radio-Canada.

In Toronto the leading figures of radio were now turning their talents to television.

Johnny Wayne and Frank Shuster, who had been Canada's favorite comedians since their radio program began in 1946, became television stars as well; in the 1970s they were still English Canada's reigning comedy performers. In drama the transfer was more difficult. The programs that seemed so good on radio were not so effective on television, particularly against the rigorous competition from American stations.

There was a great deal of activity in CBC television drama in the 1950s and the early 1960s but it only occasionally won sizeable audiences. American programs, produced with much more money and therefore more professionally made, tended to drown out the Canadian voices. In the 1960s, on English television, drama was given little emphasis by the CBC; as a result, many of our best directors and performers left Canada for the United States. In the mid-1960s public affairs dominated English television: for a time *This Hour Has Seven Days*, a spectacularly controversial Sunday-night program, was the most-talked-about television show in Canada. In the mid-1970s the CBC began another serious attempt to revive TV drama with, among other things, a successful serialization of Mazo de la Roche's *Jalna* books.

Even in the earliest days, CBC television had its successes in drama. In 1956 it introduced one of the most popular writers of his generation. Arthur Hailey, an immigrant from England, was a sales executive in Toronto when he sat down in his spare time and tried to write a play. He imagined a dramatic situation: the pilot and co-pilot of a passenger aircraft on a cross-Canada flight are both incapacitated by accidentally poisoned

food. There is only one man left on the plane who can fly, a passenger who flew fighter aircraft in the Second World War. The man has never handled a passenger plane before and must be guided to his landing by the control tower in Vancouver.

Hailey took his script to the CBC's *General Motors Theatre*, then a weekly hour-long program whose script editor was Nathan Cohen. There it was directed, under the title *Flight into Danger*, by David Greene, with James Doohan as the volunteer pilot. It was probably the most successful television or radio show ever created in Canada. It drew a huge audience in this country, was broadcast in the United States, then was repeated again and again in European countries. It became a novel, a magazine story, and a movie, then a movie again. In 1974 it showed up once more, in altered form (the stewardess now taking the controls), as part of *Airport '75*, the sequel to the movie version of Hailey's best-selling novel, *Airport*. Hailey himself moved on from Canadian television to American shows, then settled down in the Bahamas as one of the richest and most successful popular novelists of his period.

At the end of the 1950s Canadian television was about to go through significant changes. The Royal Commission on Broadcasting (the Fowler Commission) reported in 1957 that the CBC would function better with competition from private television and that Canadians should have a wider choice of service. Under the newly created Board of Broadcast Governors, new stations began appearing in a number of major cities, stations that offered an alternative Canadian service. In 1961 a private network, CTV, appeared for the first time.

In 1968 the federal government created a new body, the Canadian Radio-Television Commission. This was another turning point for broadcasting. The CRTC, under its first chairman, Pierre Juneau, created the atmosphere in which Canadian broadcasters now function. It has insisted, far more than earlier authorities did, that Canadian content play a major role in Canadian broadcasting. It demands that networks and stations, both CBC and private, devote considerable parts of their prime time viewing hours to Canadian programs. It demands that radio stations present a substantial number of records by Canadian performers and composers – and this has greatly spurred the Canadian recording industry. It demands that cable television operators, rather than just transmitting the available signals from other stations, take the trouble to produce their own programs. This has meant that many political, ethnic and community organizations have a place on television for the first time.

The CRTC has not created overnight an ideal environment for Canadian broadcasters and their audiences. As Pierre Juneau said, building a suitable broadcasting system for Canada is a long-term program, to be accomplished only with great and persistent effort. Foreign domination is still the most obvious characteristic of our broadcasting system. But, as Juneau once said, "Look, we either have a country or we don't. Let's decide." Following from this statement, he and his fellow members of the CRTC made Canadian content first on their list of priorities.

But these are only the most obvious aspects of Canadian broadcasting, the controversies and events that impress themselves on the public. Broadcasting in Canada is more diverse

than any brief survey can indicate.

CBC radio, for instance, was one of the hugely successful public enterprises of the 1970s. Programs like *As It Happens* with Barbara Frum, and *This Country in the Morning* with Peter Gzowski, provided for listeners some of the best journalism available in any form and created across the country bonds of community and loyalty by discussing the major issues of the times and broadcasting the words of important national personalities. Canada has never had a national newspaper and its national magazine industry has often been feeble; but CBC radio, operating with great initiative and independence, has become in a sense our national journalism.

Few Canadians hear of the International Service of the CBC, yet its radio programs go out by shortwave in eleven languages to Europe, Africa, Australasia, the Caribbean and Latin America. In the 1950s the CBC opened its Northern Service for the scattered residents of the Canadian North. It brings to the north national

network programs and produces local programs not only in English and French but also in two Inuit dialects and the Indian languages of Slave, Cree, Chipeweyan and Loucheux.

At Big Trout Lake (population 700), in far northern Ontario, the Ayamowin Communications Society owns a tiny station, CFTL-FM. If you were there, and if you understood Cree, this is the sort of thing you could hear on CFTL:

> **Sam killed a moose in Sachigo today. Muskrat Dam says nothing is happening and everyone's going to bed. George Barben flew into Bearskin Lake today from Weagamow to visit his mother . . . I've got a message here. Maria MacKay wants Elija to bring a baby bottle from Jessia's place as quick as possible.**

CFTL is community radio of a very special kind. It was established by the Department of Communications and the government pays for it; but it's controlled by local people, mainly Indians. This wasn't true at the start. In the beginning white people ran it, but gradually the Indians took over. First the older Indians began to come on and talk about their lives and traditions, drawn out by a young Indian who had been educated in the south. Then a trapper decided to start a noon-hour talk show. Eventually the Indians were doing most of the running of the station and most of the talking, and CFTL had become for them a kind of community lifeline.

The Indians use CFTL as a news exchange, a way to inform each other of their traditions, a means of community self-expression. Paulette Jiles, a Toronto poet and broadcaster who worked for a while at Big Trout Lake, has written that people there use their station to "create a whole new concept of radio. Slow-paced, no advertising, in the native language . . . Radio where people yawn loudly and complain they're going to close up if the next volunteer doesn't get here. Radio where an older lady crashes in and says she wants to say something about that call-in show that was broadcast yesterday and the mike is handed to her."

When death comes to Big Trout Lake the people use the station as part of their mourning. In the case of one death, Jiles writes, the station "remained silent until the elders came to the radio station and presented a long eulogy of the goodness and uprightness of the deceased. The man's wife then came on and sang some hymns . . . The radio in a crisis becomes a meeting place."

Broadcasting in Canada ranges from television networks with audiences in the millions to isolated little radio stations which may reach only a few hundred people on their best days. But that phrase from Big Trout Lake sums up the essence of it: broadcasting, in a country with a population spread as widely as Canada's, is a meeting place.

Index

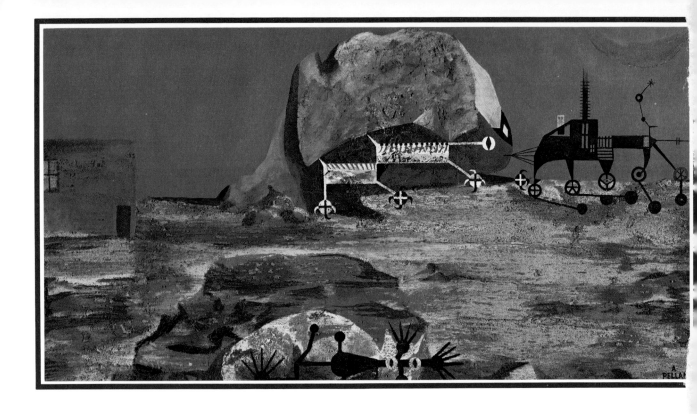